HAUNTED
CLEVELAND

HAUNTED CLEVELAND

BETH A. RICHARDS AND CHUCK L. GOVE

Haunted America

Published by Haunted America
A Division of The History Press
Charleston, SC 29403
www.historypress.net

Front cover: *David Grim, via Flickr.*
Back cover, top: *Chuck L. Gove*; *bottom*: *Courtesy of Riverside Cemetery.*

First published 2015

Manufactured in the United States

ISBN 978.1.62619.972.9

Library of Congress control number: 2015943188

Notice: The information in this book is true and complete to the best of our knowledge. It is offered without guarantee on the part of the authors or The History Press. The authors and The History Press disclaim all liability in connection with the use of this book.

We would like to dedicate this book to all the guests we have had on our Haunted Cleveland Ghost Tours over the years. We are grateful for the stories they have shared with us and the pictures they swore they would send us!

CONTENTS

ACKNOWLEDGEMENTS

W e would like to thank our families for their support during this project and all the years of tours. We especially want to thank our spouses, Rita and Paul, for never minding our Friday nights together and all the phone calls and texts.

An enormous thank-you has to go out to all the people who have helped us out with this book. Without their help, time and stories, this wouldn't have been possible: Tim Leslie and Tim Daley from Soldiers' and Sailors' Monument, Tom Armelli and Bob Cermac and the board of trustees from the Cleveland Police Museum, Gregory Kapcar from Riverside Cemetery, Steve Korpos and Charlie Sedgley from Midwest Railway Preservation Society, Kristin Roediger from Grays Armory, Paul Farace from the USS *Cod* and Carol Lee Vella, retired from Playhouse Square.

Thank you to the Cleveland Public Library Photo Collection for some great photos and guidance.

Thank you to all our guests who shared stories with us over the years, and thank you to our best guests ever, Karen Guder and Harold Hileman, for coming back year after year and telling us it's the best tour ever!

Thank you to Beth's boss, Mary Lou Mellinger, for all the time off to work on this and her proofreading skills. Any mistakes I may have made were certainly not her fault!

Thank you to the guys from A&E for their help over the years, and a special shout out to Joel Craig for his photos.

ACKNOWLEDGEMENTS

Thank you to Bonnie Brihan for freezing to death with us in pursuit of a good picture.

And finally, thank you Krista for your help, guidance and patience through this process.

INTRODUCTION

I have always believed in ghosts, and Chuck has always loved Halloween. We both love Cleveland history, so this was a match made in—well, I would say heaven, but I guess "another world" seems more appropriate. We have over the years combined all these things and shown our tour guests the creepy side of Cleveland.

Since its founding, Cleveland has gone through many changes and many nicknames. We have been the "Best Location in the Nation" down to the "Mistake on the Lake." But Cleveland is bringing itself back and building itself into a city to be reckoned with again.

Moses Cleaveland and his surveyors arrived at the mouth of the Cuyahoga River on July 22, 1796, and decided this was the perfect location for the capitol city of the Connecticut Western Reserve. In October of that same year, Moses Cleaveland returned to Connecticut and never returned to the settlement that he established and that his surveyors subsequently named after him.

There were only three original settlers who stayed in Cleveland through that first winter. Two of them were Job Phelps Stiles and his wife, Tabitha. Tabitha gave birth to their son, Charles, and they lived at Lot 53, which is now the corner of Superior Avenue and West Third Street. They later moved to higher ground to escape malaria.

Cleveland was incorporated on December 23, 1814, and Lorenzo Carter, one of the early settlers, made Cleveland a solid trading post. He was also one of Cleveland's first peace officers.

In 1831, the spelling of the name of the city was changed from Cleaveland to Cleveland. An early newspaper needed to drop the *A* so the name would fit on its masthead. The spelling stuck; the newspaper did not.

In 1822, John Willey came to Cleveland, where he established himself and wrote the Cleveland Municipal Charter. He was elected the first mayor of the city and served for two terms.

The city really started to grow in 1832 with the completion of the Ohio and Erie Canal. This allowed the city to prosper due to an easier system of trade and import and export of items.

When the Civil War finally broke out, it brought an economic boon to Cleveland. In 1863, 22 percent of the navy ships built for use on the Great Lakes were made here in Cleveland, and by 1865, that percentage grew to a whopping 44 percent. The Civil War launched Cleveland as a major manufacturing city, and by 1870, the city's population had doubled.

In 1920, Cleveland was the fifth largest city in the United States, and the Cleveland Indians defeated the Brooklyn Robins in the World Series. In 1927, the Van Swerigen brothers began construction on the Terminal Tower to increase train travel into the city.

When Prohibition took effect in Cleveland, it brought about the rise of Cleveland's organized crime syndicate. The Sugar War started, and the Mayfield Road Mob came out on top as the city's biggest bootlegging operation.

The Great Depression took its toll on Cleveland, and mob activity increased throughout the city. At this time, Mayor Harold Burton brought in Eliot Ness, of Chicago fame, to be the city's new safety director. He felt Ness could clean up the city. Eliot Ness managed to bring illegal activity down 38 percent in a year.

Ness's career in Cleveland was brought to a halt by the Torso Murders. He left Cleveland after this but returned to run for mayor in 1947, but he was defeated by Thomas Burke. People said if he had run sooner, he would have won, but his failure in solving the Torso Murders made him lose the public's trust.

Cleveland became known as the "Best Location in the Nation" until 1969, when the Cuyahoga River caught on fire, earning Cleveland the nickname the "Mistake on the Lake."

In the 1970s, Cleveland was opened to more ridicule with the election of Mayor Dennis Kuchinich, the "boy mayor." Under Kuchinich's leadership, Cleveland became the first major American city since the Great Depression to default on its financial obligations.

When George Voinovich became mayor, he brought the city out of financial ruin and started a major revitalization of the city.

Cleveland is undergoing a renaissance right now, becoming a must-see city. For the reason behind this, I believe we have to look at Cleveland's history and realize Cleveland has always been a city filled with can-do people who believe in the city and its potential.

Through the years, we have been able to collect story after story and haunted location after haunted location here in Cleveland and share them with Clevelanders and visitors to the city as well. We hope to give them a glimpse into the fascinating history our city has to offer.

We have had many experiences on our tours over the years that prove to me that something else is out there, and I think these have also made a few other believers as well. If nothing else, we have shown off Cleveland at its best and creepiest. We hope you enjoy these stories that we have to share with you.

CHAPTER 1

FRANKLIN CASTLE

Looming over Franklin Boulevard on Cleveland's near west side is a house that can only be described as a castle. Legend says it is the most haunted house in Cleveland. Franklin Castle was built for wholesale grocer Hannes Tiedemann. The Tiedemann family resided at this address from 1866 through 1895, but this house was not built until 1881. It was designed by the architectural firm Cudell & Richardson, the most prominent firm in Cleveland at the time, and is the only private residence the firm ever designed. This massive sandstone Queen Anne–style home, complete with a corner tower, a fourth-floor ballroom, a wine cellar and about thirty rooms, was home to Hannes; his wife, Luise; his mother; and the rest of his growing family from 1881 through 1895.

Hannes Tiedemann was a partner in the wholesale grocery Weideman & Tiedemann beginning in 1864. He sold out in 1871, and in 1883, he became founder and vice-president of the Savings Loan & Trust Company.

The Tiedemanns enjoyed the first few years in the house, and their family began to grow. They had a son, August, and a daughter, Emma. They lost three other children in infancy. Tragedy struck on January 15, 1891, when they lost Emma; she is believed to have died due to complications with diabetes. Hannes's mother, Wiebeka, passed away shortly after Emma, and it is believed she died of natural causes. During this time, Luise Tiedemann was understandably grief-stricken, and Hannes began to add hidden rooms to the home and other decorating touches to help alleviate his wife's grief, although there are others who say that Mrs. Tiedemann

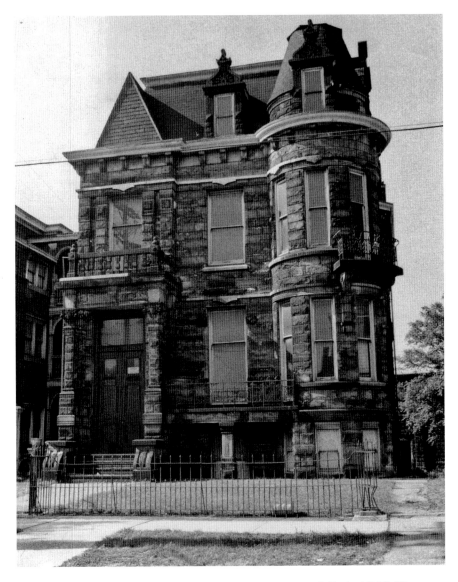

A photo of the exterior of Franklin Castle, circa 1970s. *Courtesy of Cleveland Public Library Photograph Collection.*

began to concentrate on the house and add hidden rooms and passages so she could avoid her overbearing husband.

Rumors ran rampant that Hannes was not going to win the husband of the year award. It was common knowledge that Hannes carried on with

the servants and possibly other ladies with shady pasts. There were even stories that Hannes strangled one of the servants when she informed him she was going to be married. The servant girl was believed to be named Rachel, and she is the spirit that people have heard choking in the turret room. She is also referred to as the "Lady in Black." It is also said that Hannes hung a girl in the rafters of the ballroom for sexual promiscuity. Rumor had it that Hannes caught the young girl in bed with his grandson. Another story of this incident is that the young lady had some mental issues, and Hannes felt he should put her out of her misery.

When Luise passed away from liver trouble in 1895,

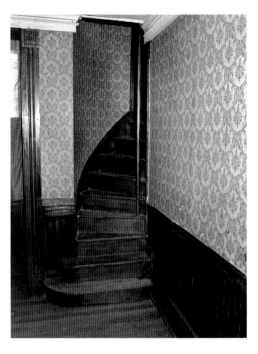

Photograph of one of the so-called secret passages within Franklin Castle. It was really used by the servants to answer the front door without disturbing the family, circa 1970s. *Courtesy of Cleveland Public Library Photograph Collection.*

Hannes was left all alone in this magnificent home. He sold the house in 1896 and moved to another grand home on Lake Road with his new bride, Henriette, a young waitress he had met at a German resort. The marriage did not last long. They divorced, and Hannes Tiedemann passed away alone after suffering a massive stroke in 1908.

The house was sold to the Mulhauser family and was then sold again and became the headquarters to the German American League of Culture. There are rumors that this group was not what it seemed and that it actually murdered some members in one of the hidden rooms, although there is no proof of this occurring. There are no stories of paranormal happenings at this time.

In 1968, the Romano family purchased the house with a view to turning it into a bed-and-breakfast. Their tenure in the house only lasted until 1974, and this is when the stories of strange happenings started. Sam Muscatello bought the castle with the dream of turning it into a

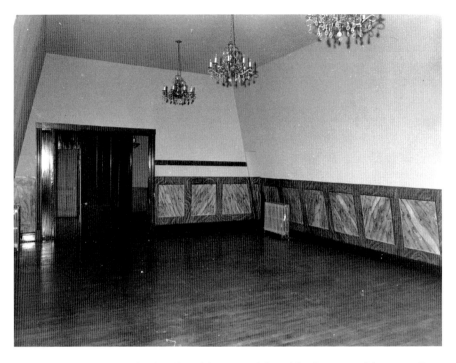

The ballroom in Franklin Castle, where it is rumored the spirit of a young girl appears. It is believed she was hanged in the rafters of the ballroom, circa 1970s. *Courtesy of Cleveland Public Library Photograph Collection.*

church. Sam became aware of the house's history and began to take people on tours of the house. He sold the house to a doctor, who in turn sold it to Cleveland police chief Richard Hongisto. Hongisto and his wife only lasted in the castle for one year before selling it to George Micerta. Micerta had not heard of the house's haunted history; he bought it just because he fell in love with its architecture. He became aware of the strange stories about his home shortly after he moved in, and he also began conducting tours of the house and encouraged people to write down in a journal any strange occurrences they encountered while in the house. In March 1982, Franklin Castle was put on the National Register of Historic Places. The amazing history and architecture of Franklin Castle was to be preserved.

Micerta claimed he had no encounters in the house, but in 1984, he sold it to Michael "Mickey" DeVinko. Mickey DeVinko, Judy Garland's fifth husband, began restoration of the house, going so far as to find the original blueprints and front door key, which still worked. He even located some of

the original furniture. DeVinko was very comfortable in the house; he felt that none of the spirits bothered him because he was restoring the house for them. He put the house back on the market, and it was sold in 1999. The new owner, Michelle Heimberger, continued to work on the house, but unfortunately, there was a fire that caused extensive damage to the ballroom and roof.

For a time after that, a developer tried to continue the restoration with the idea of turning the castle into a private club called the Franklin Castle Club. This idea eventually died out when the carriage house caught on fire in March 2011. The house was again put on the market and sold to a woman interested in living in the ballroom and turning the lower floors into an art gallery, according to the rumor mill. There has been extensive work done and hopefully more to follow.

There are no reports of ghost activity until 1968, when the Romano family took over the house. Those reports began almost immediately, with the children asking their mother if they could take a cookie upstairs to the little girl, who some say is Emma, because they felt bad she was crying so hard. Mrs. Romano heard organ music in the house, even though the organ had been removed years before. She heard conversations taking place in empty rooms, perhaps echoes of long-ago occupants of the house? Finally, the Romano's parish priest convinced them to leave, as he felt there was something wrong in the house. He felt that most of the activity was directed at Mrs. Romano, that maybe Luise Tiedemann was reaching out to her, and he felt it was better for the family if they left.

During one of the many renovation periods, it was reported that human bones, those of a baby, were found in one of the hidden rooms, which, to some, confirmed the reports of a baby's cry being heard in the house. It also brought into question the doctor who had once lived in the house. Almost immediately, he became a sinister figure in the history of the house, with people speculating that he had been performing unspeakable experiments there.

When tours were being done in the house during the 1970s, one tour guide reported that a secret passage way kept popping open. The particular passageway was rumored to have hidden a still during Prohibition. Apparently, the spirits wanted some other spirits recognized in the house. This fits with the rumor that at one time there was a secret tunnel that led from Franklin Castle to a home located behind the house and then another tunnel leading to Lake Erie. These tunnels were said to be used to smuggle bootleg liquor.

The front door of Franklin Castle, where a newspaper delivery boy once claimed he saw a woman in white float through. *Courtesy of Beth A. Richards.*

Another secret passage located in the castle. This one was rumored to contain a still during Prohibition. The tour guide featured in this 1975 photo was quoted at the time in the *Plain Dealer* as saying that the door would often pop open on its own. *Courtesy of Cleveland Public Library Photograph Collection.*

A newspaper delivery boy claimed that one morning when he was delivering the paper, a woman in white, whom many believe to be Mrs. Tiedemann, floated through the front door toward him. Many people have seen and heard a woman in black choking in the turret room; she is believed to be a servant girl, Rachel, allegedly strangled by Hannes Tiedemann. There have also been numerous sightings of a young girl, believed to be Emma Tiedemann, standing at the upstairs windows. I actually had a guest on one of the tours who grew up around Franklin Boulevard and saw this little girl in the windows on many occasions on her way home from school.

Chuck has always felt a special connection to the castle due to the fact that when he was a small child his mother and aunt belonged to the Cleveland German Mannerchor Club and went to weekly events at Franklin Castle. Chuck's mom's favorite event was the annual Christmas party that was held in the castle's ballroom, and she took Chuck with her every year. Mrs. Gove said it was the social event of the year, very memorable, but Chuck does not remember a single time that she took him there. Despite his vivid childhood memories, the castle memories elude him. In fact, his first memory of the inside of the castle is from 2000, when we were invited in for a private tour.

We had taken our tour to the castle previously, but our guests could only have a sidewalk view. Every year, I would say that I know the castle is amazing, but I am not sure that I would even go in if I had the chance. It just seemed terrifying to me. But when Chuck and I got the call to come for a tour, we literally dropped everything to get over there. When we got there, we were so excited, and then when we got to the side door, I thought, *Do I really want to go inside?* The resounding answer was, *Yes, are you crazy? You have a chance to go inside, don't blow it!* The most amazing thing was that I felt very welcome inside the house, and it didn't seem scary to me at all. Chuck and I just stood and stared like two kids in a candy store and then began our tour.

We were lucky enough to meet the developer and use the castle on a number of our Haunted Cleveland Ghost Tours, and we had many interesting photos taken and a handful of experiences during our time there. One story that the developer told us before we started our tours was this: he had gone into the castle one day and noticed that all the utility lights were out. He went to the circuit box that was located back by the furnace in the area of the house most destroyed by the fire, so needless to say, it was very dirty and everything was covered in soot. He flipped the breaker, and the lights came back on, and then he sneezed. When he turned around, sitting on a soot-covered workbench was a blindingly white handkerchief. He picked it up, thanked whomever or whatever had left it for him and left the house. He

A first-floor hallway in Franklin Castle, leading back to the first-floor room where the light fixture began to swing. This part of the castle was damaged in the fire in 1999. *Courtesy of Beth A. Richards.*

put it on the dashboard of his car, and when he went back to get it out of his car, it had disappeared.

In the 1970s, radio host John Webster came to do a special Halloween show from the castle. He stated that as he was walking through the castle, he was carrying his tape recorder on a strap around his shoulder, and as he headed up the front staircase, it was ripped from his arm and thrown down the stairs. He continued on to do his broadcast, and when they listened to the playback of the show, they could hear a sinister laugh throughout the broadcast. The scary part is that they did not hear it during the actual broadcast, only on the playback.

I also heard another story about a TV show that came to spend the night in the castle and do a show about the haunting. This was a local morning news show called *The Morning Exchange.* The crew came in the night before to start filming in the hope they could pick up some video evidence of the spirits that live here, and they did. One of the cameramen didn't make it through the night after he was filming in a back room on the first floor and the ceiling light fixture began to swirl around in ever widening circles all on its own. He was kind of all right with it until it suddenly stopped and began to go in the other direction. That is when he hightailed it to the door and never came back.

Chuck and I were lucky enough to be invited to spend the night in the castle; it was to be in conjunction with a local morning radio show on Halloween. We arrived at midnight and walked all around the castle, filming as we went, and we finally settled down to sleep around 2:00 a.m. in the turret room, which, I found out later, was where the Tiedemann family laid

out their dead. We knew that the radio setup technicians would get there around 4:00 a.m. to get things going.

The developer and I fell asleep pretty quickly, but Chuck had a harder time, and just when he started dozing off, he heard a man and woman conversing softly in the hallway off the room. Wondering what the developer and I were talking about, Chuck got up and headed to the hallway. In doing so, he suddenly realized that I wasn't talking—he had stepped over me. The developer also wasn't talking, as he was sound asleep a couple feet away, and no one else was in the house. As the hair on the back of his neck stood up, he realized that we were still alone, so, doing what any intelligent person in that situation would do, he pulled his sleeping bag over his face and tried desperately to pretend it hadn't happened.

When the radio hosts and crew showed up to start the live show, they decided it would be funny to play a trick on me and bring out a Ouija board. I had told one of the hosts that I hate Ouija boards and will not be in a room where one is being used. When they got started, I went outside. They asked a question of the board and lost their live feed to the station, both the back up and the regular one. They regained the feed and continued to ask

Franklin Castle front drawing room, where the Tiedemann family dead were laid out, 1975. *Courtesy of Cleveland Public Library Photograph Collection.*

questions, but then they again lost the feed. Just as they regained it, there was a loud crashing noise upstairs, and they wisely decided to stop using the Ouija board.

I had my own experience at the castle on one of our tours. I was standing in the backyard sharing stories about the castle with some of our guests. They were standing in front of me in a semicircle, when all of a sudden I was pushed from behind, not terribly hard but enough to get my attention and move me forward a step or two. At first I thought I had been bumped into by another guest, but the look of shock on the faces of the people I was talking to was enough to tell me that whatever had pushed me couldn't be seen.

We did a tour for a local radio station one year, and as a surprise we arranged for them to go into Franklin Castle. They were so excited, but as the tour went on, their excitement turned into uneasiness. Chuck was walking behind the tour, and he said for some reason the floorboards started moving, basically bouncing up and down. We had been in the castle many times, and even though the house was in a state of disrepair, the floors were still quite solid, and this had never happened on any of our other tours. Apparently the spirits inside the castle did not appreciate a late-night visit. Chuck said the people in front of him turned around and told him to stop making the floor move because it wasn't funny, and he tried to tell them it wasn't him, but they weren't buying it. I never heard anyone complain of this activity again on any of our other tours, so maybe the spirits didn't get the response they wanted.

One night while getting ready to take a group inside for their tour, I found myself talking to the developer's mother, a very down-to-earth lady, and she said, "Hey Beth, I have a story for you. We were up in the ballroom talking about the plans for the castle, and we started down the stairs and something put its hand on my shoulder and gave me a little shove, not enough to push me down, just enough to get my attention." She told me then that she told her son that maybe whoever was still in the house didn't care for the plans he had for it.

On another tour of Franklin Castle, I had taken the group down to the cellar, and we were standing in the servants' area by the hidden staircase for the front door. This room also had a fireplace in it, and hanging above the fireplace was a mirror. People were busy snapping pictures all around the room and getting a million orbs in each photo. I felt bad, but I had to tell them that the orbs were probably just dust. However, there was one photo that caught my eye. In the corner of the mirror, there was a smoky figure that resembled a dog or a wolf. This room had nothing on the walls that

A present-day photo of the secret staircase, which has fallen into a state of disrepair. *Courtesy of Beth A. Richards.*

resembled anything like what was in the picture. There was no mist or smoke of any kind visible to the naked eye that could form this figure, so I could only stare at the picture and move slowly away from the mirror.

Chuck stopped in and was talking with the construction crew. He told the man in charge about some of the experiences we had had in the house, and the man turned to the crew and told one of the guys to come over and tell Chuck about his experiences. The young man told Chuck that he had been working in the ballroom when all of a sudden a brick flew across the room and almost hit him. This happened to him twice while in the ballroom. Perhaps the spirit of the young lady who is reported to have been hanged in the ballroom found the constant activity annoying.

Is Franklin Castle cursed? Is Franklin Castle haunted? I can't be sure of either. I can only tell you the history and legends that surround it and hope that whatever lives in there approves of what is going on now so this beautiful house continues on in the future of Cleveland.

RIVERSIDE CEMETERY

R iverside Cemetery was the west side's answer to the opulent Lakeview Cemetery on the city's east side. Riverside is on land that was purchased from Titus Brainard in 1875. It covers 102.5 acres and is truly a most beautiful and peaceful place.

Riverside opened to the public on July 8, 1876, and was dedicated on November 11, 1876. The dedication ceremony was attended by many dignitaries; one of them was president-elect and Ohio governor Rutherford B. Hayes. The first president of the Riverside Cemetery Association was Josiah Barber Jr., and James A. Curtiss became the first superintendent.

The chapel, built in 1876 and designed by Bruch & Monks architectural firm at a cost of about $3,855, is on the National Historic Register and is the only original structure left on the property. In 1898, the addition of the three leaded-glass windows, a porte cochere and a covered rear stairway leading to the basement vault was handled by Steffens, Searles & Hirsch, and they match the original architecture perfectly. The chapel has a vault underneath capable of storing up to thirty caskets because in those days all graves had to be dug by hand, and our Cleveland winters sometimes made that difficult. The chapel was built to handle nondenominational funerals and truly is a most peaceful place. It was restored in 1998.

The office is also on the National Historic Register. This red brownstone building replaced the original wooden building. Construction on this Romanesque-style building started in 1896 and was completed in the spring of 1897. The office is truly beautiful inside and out, complete with three fireplaces.

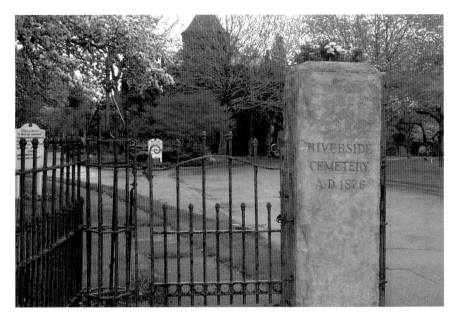

The front gate at Riverside Cemetery. *Courtesy of Riverside Cemetery.*

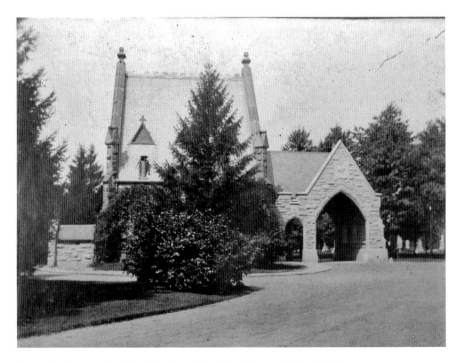

An early photograph of the chapel at Riverside. *Courtesy of Riverside Cemetery.*

There are many notable inhabitants of Riverside. John Richardson, of Cudell & Richardson architectural firm, is laid to rest here. He designed not only Franklin Castle but also Franklin Circle Church. This is also the resting place for many of the Rhodes family, including James Ford Rhodes and Robert Russell Rhodes, whom we will talk about in upcoming chapters. Several of the early Cleveland brewing families, such as the Schlatter family and the Leisy family, are laid to rest here. In concert with Case Western Reserve University, since 1947 the cemetery has also had a special section where the cremated remains of people who have donated their bodies to the medical school are laid to rest. There is a special private service for the families of these generous souls once a year in the spring.

One very interesting family laid to rest here is the Tiedemann family, original owners of the Franklin Castle. There is a story I have heard concerning the spirit of Hannes Tiedemann. People have reported seeing an elderly gentleman lingering near the front gates of the cemetery. When asked if he is OK, he asks for a ride to Franklin Boulevard so he can see his daughter, but strangely enough, when they near Franklin Castle, the elderly gentleman disappears from the car.

We have enjoyed using Riverside on our tours, not only for the beautiful surroundings but also for the rich history it provides. While no one on a tour has ever reported seeing the spirit of Hannes Tiedemann standing at the front gate, I can guarantee we would definitely pick him up.

We have had many photos taken with orbs surrounding our guests. On one visit, one of our guests was using dowsing rods (copper rods used to locate spirit energy, among other things), and she claimed the rods had led her to a headstone that actually had her family name on it, and believe me, it was not a common name. A friend took a photo of her, and there was a large orb hovering above her hands.

When we first approached Bill Halley (the retired general manager) about using Riverside on our tours, he was enthusiastic about it but informed us we would have to clear it with Ken Langley, the caretaker, since it would mainly involve his participation. We talked to Ken, and he was all for it. I think the folks who work at Riverside are really proud of the legacy that they tend and the historic significance of it. So we set up all the times with Ken, and we thought that was that. What we didn't realize was that Ken has two daughters, Ashley and Amanda, who were pretty young at the time, and they wanted to be involved in the tour.

The first night when we went to the Tiedemann family plot, I told my stories concerning the family and gave our guests the opportunity to explore

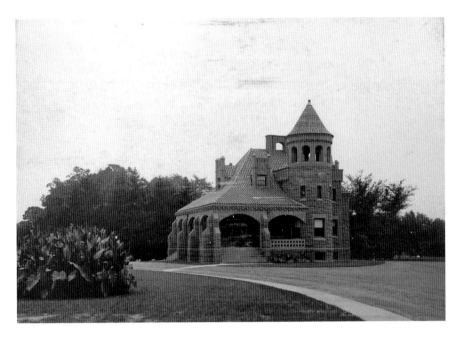

An early photo of the office at Riverside Cemetery. This building is on the National Register of Historic Places. *Courtesy of Riverside Cemetery.*

on their own. I was standing by the bus when a woman approached me and asked me who the woman in the wedding dress and the young man walking through the cemetery were, and I had no idea what she was talking about. I looked out across the cemetery, and she was right, there was a young woman and man in wedding clothes traipsing around. I began to inch toward the bus, ready to abandon all our guests, when Ken came up to me and said, "I hope you guys don't mind, but the girls wanted to help out with the tour." I started to laugh and said, "No, I knew it was them all the time!" No need for anyone to know that the two "ghosts" had freaked me out as much as it had the tour guests—I was supposed to be the professional here.

As funny as that night was, the next week was even better—at least for me, but maybe not for the girls. We had a younger group on the bus that night, and they were all having a great time. We got to Riverside, and they were really interested in being in the cemetery. Even though it was only a week later, daylight had faded by the time I set them loose on their own with the dowsing rods, and I had completely forgotten about the girls. There were two couples exploring when they saw the bride and groom "ghosts," and I heard a yell. I turned to see what was going on, and imagine my surprise

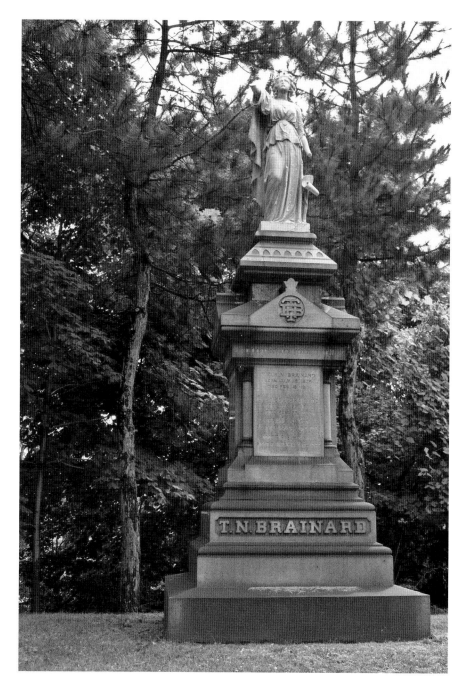

A photograph of one of the beautiful monuments at Riverside Cemetery. *Courtesy of Riverside Cemetery.*

when I saw the bride and grooming running as if their supernatural lives depended on it with two men in hot pursuit! Luckily, the girls hopped into their parents' waiting station wagon, eluding their captors. I was running behind the two guys yelling, "Wait, wait! They're only kids!" As I look back on it now, all I can think is that we must have looked like a really bad episode of Scooby-Doo.

On one tour in late October, Chuck had to follow the bus in his private car, and he met us at our first stop that season, which was Riverside. It was already dusk when we arrived at the cemetery, so I knew that by the time we left it would be completely dark. Chuck pulled up, and I got out at the Tiedemann family plot and began my stories. When it came time to leave, I supervised loading the bus, Chuck said he would meet us at Grays Armory and we pulled out of the cemetery. I assumed Chuck would be right behind us, so imagine my surprise when we got to the armory and he wasn't there. I ushered everyone in and went outside to wait and check my phone. There were five missed calls, all from Chuck. I called him back immediately, and to my relief, he answered right away. I barely had time to get hello out of my mouth when he launched into his story. It was pitch black, and he was all alone in the cemetery. He had gotten in the car to leave the cemetery, but his car wouldn't start. He tried again, to no avail, and his car went crazy—the horn started beeping, lights flashing, the whole package. The worst part was that when he got out to lift the hood, he unhooked the horn, but it still continued to beep, and he was still totally alone in a pitch-black cemetery. Lucky for him, Ken, the caretaker, showed up to save the day. But strangely enough, once Ken got there, the car started right up.

We were very lucky one evening to have Bill Halley come out and join us on the tour and show us what the cemetery workers use dowsing rods for. He explained that all cemeteries have a set, and they aren't used to detect spirit energy; rather, they are used to detect graves. He brought his dowsing rods out to the Tiedemann family plot and showed us that the rods cross when they detect the opening for the grave and open back up when there is no disturbance in the ground. What was most interesting was that in one area of the Tiedemann plot, Hannes, Luise and Emma are laid out in a straight line—or so it seems. For some reason, Emma is actually buried almost sideways, a fact that was shown by the dowsing rods and is verified in the historical records of Riverside. Halley explained that cemeteries often use dowsing rods to make sure that there is indeed open space in some of the older sections, and they can be used to find out where people are laid to rest

in older cemeteries where the headstones may be missing. It was amazing to see the accuracy of the dowsing rods.

Riverside Cemetery is a wonderful place to explore the history of the city and some of its most interesting historical figures, and the staff members have created some wonderful tours to showcase its history. Please remember that all cemeteries close their gates at sundown.

CHAPTER 3

THE COUNTY ARCHIVE BUILDING/ ROBERT RUSSELL RHODES MANSION

Located at 2905 Franklin Boulevard is an enormous Victorian Italianate mansion built in 1874. This magnificent mansion was originally the home of Robert Russell Rhodes. Robert Russell Rhodes was the great grandson of Josiah Barber, one of the early settlers of Ohio City. Robert Russell was a businessman, heir to his father's numerous businesses, but he was listed in the 1880 census with his profession simply noted as coal dealer, not millionaire. He grew up in the area that was referred to as Franklin Circle, and when he got married, he built his own home there. At that time, Franklin Circle could have been called the Rhodes compound, as all the homes around the circle were owned by either other members of the Rhodes family or close acquaintances, and the land that all these homes were built on was donated by Josiah Barber, Robert's great-grandfather.

Across the street from Robert's home, his brother, James Ford Rhodes, after whom the Cleveland high school is named, built his home. This neighborhood was truly a family affair. James Ford Rhodes was also a businessman, dealing in iron, coal and steel, until he retired in 1885 and began a life of historical research. James Ford Rhodes wrote and published a history of the United States, done in seven volumes. His eighth volume, *History of the Civil War, 1861–1865*, won the Pulitzer Prize in history in 1918.

The home to the left of Robert Russell Rhodes's home is the Nelson Sanford mansion, built in 1862. It is now attached to the Robert Russell Rhodes home. Rhodes sold his home in 1888 and moved to Lakewood, Ohio, where he died in 1916.

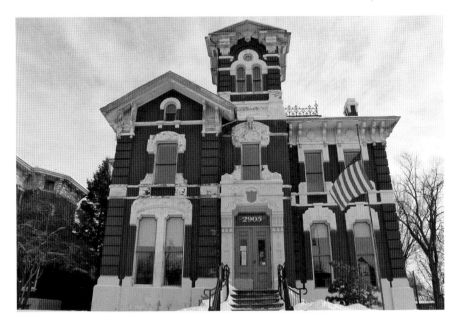

A recent exterior photograph of the County Archive Building. *Courtesy of Chuck L. Gove.*

Cuyahoga County purchased the home in 1914, and it began its life as a county building, serving many purposes over the years. It served as a juvenile detention center from 1918 to 1932. It was then converted to a nursing home in 1939 and continued in this capacity until 1962. It served as the county welfare office from 1962 to 1963 and then became a school for disabled children from 1963 to 1977. In 1977, it became the county archive building, and that is when the Nelson Sanford mansion was attached. The Rhodes mansion was used by the county, and the Sanford mansion became the Ohio City Center of the Western Reserve Historical Society.

The archive holds many records, including early county commissioner journals, marriage records, birth and death records and many more. The archive also holds certain original coroner office case files due to a flood in the coroner's office. Amongst those case files are the original files concerning the Torso Murder case, Cleveland's first recorded serial killer and most famous unsolved case.

At this writing, Cuyahoga County is looking to sell this historical building and move the archive to another location.

The Rhodes mansion has served so many purposes over the years that it is difficult to pinpoint what era its spirit comes from, but one thing is certain:

he is busy. The spirit is reported to be a little boy, and a mischievous one at that, so I believe it's a safe bet that he may be left over from the time that the home was the county detention center. He is reported to be a bit of a prankster. Staff members have reported that he likes to bounce a phantom ball down the stairs. They can hear the ball bouncing down the steps, but when they investigate, there's nothing and no one there. Aside from his playful side, he has been known to have a bit of a temper, and he rocks the front room chandelier from side to side, but a sharp reprimand from a staff member soon puts an end to his tantrums.

He also likes to entertain himself by playing tricks on people researching in the building. One woman told a story about how she was in the research room and had just had an idea about how to continue her research. She jotted a note down to herself and carried it with her back into the research room. When she went to continue her work, the note had somehow disappeared from her hand. She searched and searched and never found it. She believes the little guy got quite a kick out of his trick.

People have reported being surprised in the basement restroom by the reflection of a young boy in overalls in the mirror. When they turn around to talk to him, he simply disappears.

Because it is a county building, there is full-time security, so don't get any ideas about dropping in for an afterhours visit. One of the security officers is a retired Cleveland Police officer and related some experiences he has had with this little spirit. He says in the beginning, he found his companion a little off-putting, but now he finds him extremely helpful. There have been a few times that people have been trespassing on the property—I know, that's shocking—and somehow the little fellow finds a way to alert the guard. Whether by triggering the alarm or causing a commotion, he makes sure that nobody causes any problems in his building. The guard also stated that sometimes when working the graveyard shift (no pun intended), he has started to fall asleep, but something or someone always wakes him up.

Another great story about the building was passed on to me by Tim Leslie, a guide at the Soldiers' and Sailors' Monument, which was told to him by a friend who is a security guard at the archive. The security protocol called for a complete building search at the end of each shift, so the two guards began their search, and when they got to the elevator area, they heard something very strange: the elevator was running. Why was this strange? The elevator had been non-operational for quite a while, so there was no way it could be running. Even stranger—they could hear a child's voice and the bouncing of a ball. These security guards did the only thing they could, they quickly

vacated the building. The guard who was going on duty said to the other guard, "We may as well lock the door because I am not going back in there tonight." And he proceeded to work his entire shift, outside the building, locked in his car.

We heard a rumor that Mary Ann, a famous ghost hunter in Cleveland and the person on whom the TV show *The Ghost Whisperer* is loosely based, tried to exorcize the spirit of the little boy and help him move on, but something seems to hold him to the Robert Russell Rhodes mansion.

We have used this as a stop on our tour for many years, but we never take our guests inside. We stay outside and hope for a glimpse of the little fellow through the window, but I have never been that lucky. We did visit one day and did not have any experiences with the ghost, but I will admit that I wasn't brave enough to use the basement restroom, and I certainly did not stay for too long.

Down the street from the County Archive building and Franklin Castle is another location that has provided us with some great ghost stories. The West Side Market is at the corner of West Twenty-fifth Street and Lorain Avenue in Ohio City on the city's west side.

The West Side Market originally opened in 1840 across the street. The land for the newly opened market was donated by Josiah Barber and Richard Lord. In 1902, the West Side Market moved to its present location. Construction began in 1908 and was completed in 1912. It was designed by architectural firm Hubbell and Benes as a Neoclassical/Byzantine building with a large outdoor clock tower that can be seen from all over. The West Side Market was put on the National Register of Historic Places in 1973. Not only is the West Side Market a great place to shop for the living, but it also seems to have some spectral shoppers as well.

When we used the market on our tour, Chuck and I were told by the night guard that sometimes at night the service elevator would open on its own after the market closed. He told us that one night he ran to the room where the surveillance cameras were to see if anyone had gotten inside. What he saw was worse than an intruder. He saw a black shadow man floating down the corridor until he basically floated into a cooler at the end of the hall.

And if that isn't scary enough, he told us another story about a butcher who used to work in the building. One day the man was down in the cooler using a meat grinder to make sausage, and out of the corner of his eye, he saw another person step into the cooler. He looked over, and there was a man standing there. He had on a paper butcher's hat and an apron, but somehow this guy looked different, kind of see through. The man who was grinding

the sausage said to the newcomer, "Hi, how are you?" Unfortunately, he was saying it to an empty room because the man had disappeared in the blink of an eye. Shocked, the man forgot to pay attention to what he was doing and ended up with his hand in the meat grinder. Even after he recovered, he never returned to work there. Can't say I really blame him, do you?

The ghostly happenings are not all inside the West Side Market. There is also a spirit who has been seen outside. The story is that there was a young girl attacked and murdered in an alley right by the market. Since that time, people have reported seeing a young woman covered in blood wandering in the alley, earning her the name "Bloody Mary." One witness, a police officer, was so startled when he saw her that he ran up to ask her if she needed any help. Imagine his surprise when she promptly disappeared into thin air. But this ghostly young woman doesn't seem to want to scare people; instead, her appearance usually signifies some kind of danger. A young man reported that he was riding his bike near the alley when a girl covered in blood stepped in front of his bike. Startled, he swerved and fell over. When he got up, the girl was gone, but in her place was an open grate. Had she not blocked his way, he would have been seriously injured. He said later he thanked his lucky stars for her intervention.

I find it very interesting that there are so many hauntings in one small area of Cleveland, but since these are some of the oldest structures in the area, I guess it's only natural (or supernatural) that they have such a haunted history.

MIDWEST RAILWAY PRESERVATION SOCIETY

The Midwest Railway Preservation Society is located at 2800 West Third Street down in the Flats. It occupies the historical B&O Roundhouse, which once was the home to the Baltimore and Ohio Railroad. The roundhouse was built between 1905 and 1919 and was a fully functional roundhouse, open all day every day. This was the central service center for one of the biggest rail lines in Ohio. In the 1940s, during its heyday, this busy hub employed four hundred and boosted Cleveland's economy.

The Midwest Railway Preservation Society is striving to bring the B&O Roundhouse back to its former glory by getting all the stalls inside in working order. Currently, stalls one through four are in working order, and the group is planning to restore stalls six through ten, but unfortunately, stalls eleven through fifteen are beyond repair. The society wants this to be a full-service roundhouse, and it has done a lot of work so far.

The group's efforts are not confined to bringing the B&O Roundhouse back to life, however. These fine volunteers also restore and repair locomotives and passenger cars. Well, let me put it this way—if it is meant to be on a track, they can fix it. The society also owns over twenty pieces of vintage stock that volunteers have been busy working on. The biggest project may be the rebuilding of the 1918 Mikado steam locomotive, the 4070, which is currently underway. This locomotive was once the engine that provided the power for trains traveling through Cuyahoga Valley.

The preservation society owns many passenger cars that it has restored, including an Amtrak dining car that was used by President Jimmy Carter

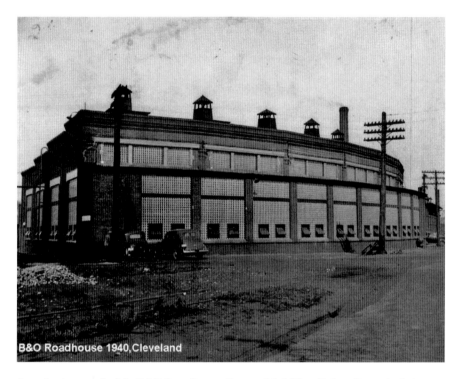

B&O Roadhouse 1940,Cleveland

An early photograph of the B&O Roundhouse. *Courtesy of the Midwest Railway Preservation Society.*

when he rode the rails before his inauguration in 1976. One of its other passenger cars with an interesting past was used in the film *The Natural*, and volunteers are happy to show visitors where Robert Redford once sat.

For our purposes, the most fascinating car the Midwest Railway Preservation Society owns is called the Death Car. It sounds ominous, and from one of the experiences our guests had, it lives up to its hype. This Lackawanna passenger car was in a horrific accident at 5:23 p.m. on August 30, 1943, in upstate New York. The accident was between a passenger train and a freight train. The engineer of the freight at the controls was going eighty miles per hour, trying to make up time, when he saw another locomotive pulling onto the track in front of him. There was no way to stop, and a collision was inevitable. As they collided, some of the cars derailed, but the Death Car slid and split the boiler of the freight engine's locomotive, blowing out the windows of the passenger car and sending steam and water into the car itself. Twenty-six passengers were killed immediately, and two other passengers died later of their injuries.

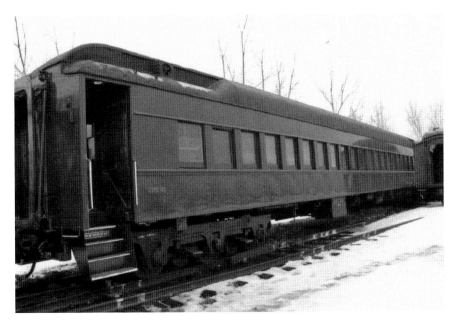

The exterior of the Lackawanna passenger car also known as the Death Car, which was involved in the tragic railroad accident that killed 126 people. *Courtesy of Chuck L. Gove.*

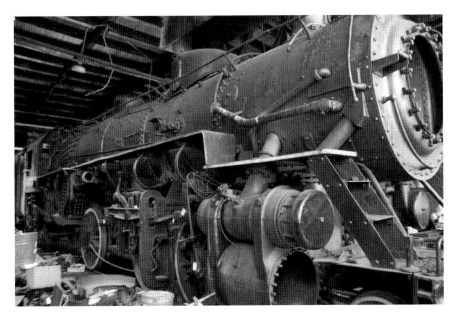

The steam engine that the Midwest Railway Preservation Society is currently rehabbing. *Courtesy of the Midwest Railway Preservation Society.*

According to the official report, another 114 people were injured, 6 of them from Cleveland.

The folks who work or have worked on this car truly believe some spirits have stuck around. When they were painting the car, the windows kept slamming shut, even if they were propped open. The volunteers also heard whispering, and they always felt like someone was watching them. Charlie Sedgley, one of the volunteers, feels that there are at least fifteen spirits keeping an eye on things. Charlie has often wondered why the spirits don't bother them more, and one time he asked them. He received a whispered word, "Fixing"—that's it. Charlie feels that the spirits must approve of the work that they are doing here.

Steve Korpos, a trustee, has led many tours through the Death Car, and on several occasions, he has been asked by visitors whether the man standing behind him in the funny suit has any stories to tell. Steve knew before turning around that he was the only person—the only *solid* person—standing there. Guests have also reported seeing a man who fit this description sitting on the roof of the car with his feet dangling over the side.

On one of our tours, one of the guests—OK, my mother—got into the Death Car and sat down next to me. Before the guide began to tell the story of the accident, my mother turned to me and said she was having a difficult time breathing inside the car. This was before she knew what had happened, and then she told me it was really warm in the car. Now, this tour was in October. October is not usually one of the warmer months in Cleveland, and I have to say it was pretty chilly in the car, so that leaves me to wonder if my mom was picking up on an echo of the horrific accident that happened inside this car. The minute she left the car, she felt 100 percent better.

We had some great orb photos taken inside the car and also one that showed a mist around one of the sleeper berths. I found that one pretty interesting because I was told there had been an earlier death in the car, an elderly woman who died in her sleep in that sleeper compartment.

Charlie told us that there was at least one death he knew of inside the B&O Roundhouse itself. An employee had died in an accident inside the roundhouse, and he must still be extremely attached to the place because he makes his presence known by moving tools and making noises, usually when people are working alone.

On another fun tour at the roundhouse, I noticed one of the men on the tour acting a bit odd. Charlie had finished telling the story about the man whose spirit occupied the roundhouse and was launching into another story when I noticed the man seemed to jump, and then he turned to look at his

wife. She was not paying any attention to him, as she was listening intently to Charlie. I watched him as he looked around at the other members of the group, and then he started to take pictures all around the roundhouse. As we were walking out to the Death Car, I caught up with him and asked him how it was going. He told me that he was enjoying himself but that he felt a little uneasy back in the roundhouse. I asked him what had happened, and he said he distinctly felt someone tap him on the shoulder. At first he thought it was his wife, but it wasn't her. He looked around to see if anyone else in their group was standing by him and playing a joke, but he didn't see anyone he knew. He started taking pictures, and when he looked at them there was a strange shadow figure that seemed to be moving around the room; every place he took a picture, the shadow was there. After he thought about it for a little bit, he seemed pleased that the spirit picked him to take his picture, but I don't see him going and spending time in the B&O Roundhouse anytime soon.

One of the best stories Charlie tells is about the ghost who got away. The crew at the Midwest Railway Preservation Society was refurbishing a car for an outside party, and every time anyone worked on the car, he or she would hear a rapping noise on the outside of the car. The workers

The railroad yard behind the B&O Roundhouse where the trains once pulled in. *Courtesy of Chuck L. Gove.*

were constantly running outside to see who was out there or if someone was playing a joke, but no, they were always alone. This went on until the car left the roundhouse and was delivered to the gentleman who owned it. The minute the car left, so did the rapper. None of the workers gave it much thought until they got a letter from the man. The message was something like this: "What is wrong with this car? I will be inside the car, and something starts rapping on the outside wall or the roof. Every time I run outside to see what's causing the commotion, it stops. I thought maybe it was kids playing a prank, but there is never anyone out there." The group at MRPS had a good laugh and let him know that they wouldn't charge him extra for supplying a ghostly rapping passenger.

The Midwest Railway Preservation Society is really trying to share Cleveland's extensive railroad history with everyone and make this a great destination for Clevelanders and visitors to the city alike. The group hosts open houses and even sponsors a paranormal investigation night. Stop in and soak up some of this incredible history, and maybe you will have your own experience in the Death Car. At the very least, you can sit in the same seat that Robert Redford did.

THE POWERHOUSE

L ocated on the west bank of the Flats, the Powerhouse has undergone many changes. Originally built in 1892 to power Marcus Hanna's line of streetcars, the Woodland & West Side Street Railway Company, it has become an entertainment spot in the Flats.

Hanna wanted to make a statement to his business rivals with this building so he commissioned the famous architect John Richardson, formerly of Cudell & Richardson, to design his building. This firm was responsible for many of Cleveland's architectural masterpieces of the time. Scottish-born John Richardson was behind the design of Franklin Castle, St. Joseph's Franciscan Church and the Bradley Building. Richardson wanted the Powerhouse to resemble the huge factories of the time in Europe, so he designed a Romanesque Revival–style building. It has large chimneys, beautiful arched windows and thick stone windowsills. In 1898, the Woodland & West Side Street Railway Company became part of the Cleveland Electric Railway Company, and as a result of that, the Powerhouse was expanded in 1901, causing the building to double in size. Unfortunately, the popularity of the city's streetcars did not last due to the automobile becoming the preferred mode of transportation, so in 1920, the Cleveland Electric Railway closed down, and with it, the Powerhouse closed, too.

The Powerhouse was unoccupied for a time, and rumor has it the homeless used it for shelter. In 1929, the Globe Street Barrel Company used the building, and it changed hands in 1970 when the Cleveland Metal Products Company used it as a warehouse.

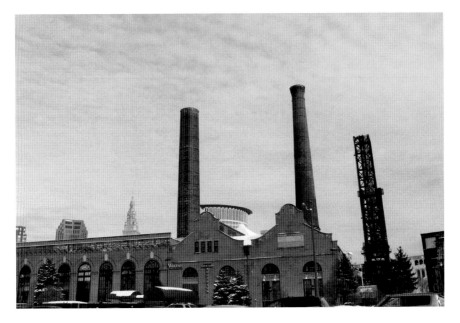

The exterior of the Powerhouse, present day. *Courtesy of Chuck L. Gove.*

In 1975, there was renewed interest in the building, but the renovation plan ran out of steam and money. Then in 1989, renovation was completed, and the building housed offices, restaurants, comedy clubs and bars. The Powerhouse is still open for business, and its most recent addition is the Greater Cleveland Aquarium.

The Powerhouse is our pickup spot for our tours, so we have been inside a time or two, and it is truly a great space. We have spoken with many employees over the years, and again, the security guards have some of the best stories about these buildings. I have come to the conclusion that the security guards spend so much time in these buildings after hours that they truly are in touch with what is going on.

One security guard told me that there is a tidy spirit in one of the offices. Apparently none of the workers in the office can leave any drawers in their desks ajar. The minute they turn away, someone or something pushes the drawer completely closed. They have experimented by leaving file cabinet drawers open, and as they walk away, they can hear the drawer being closed by an unseen hand. The more they experiment, the more emphatic the closing of the drawers becomes. Whoever this spirit is, it doesn't enjoy being tested.

Another guard shared his own story surrounding the Powerhouse. It began in his childhood. He told me he grew up in the area and was always fascinated with the deserted building—so much so that he and his friends used to sneak in and play in the abandoned structure. The building was run down, and the lower level was filled with water. Another renovation was scheduled to begin, and to get ready for it, the company had to drain the water from the lower level. He stated that while they were draining the building, he heard that they found a submerged car, and in that car, they found a body. Again, this is his story, and I have never been able to substantiate it.

He said his interest in the building never lessened, and when he heard security people were needed, he eagerly applied for a job. He told me that late at night when the building is clear of people, he hears people talking and machinery running that no longer exists. The water faucets in the bathrooms turn on and off on their own, and the toilets at times flush in rhythm. Whenever he goes to investigate, he, of course, finds himself alone.

He credits some of the activity to the body in the car that was discovered, but he says there is too much activity for one restless spirit. Who knows—maybe some of the workers from the streetcar days have come back to see what their factory has become. The thing that is interesting is that this particular security guard says it doesn't scare him, as he believes the spirits are just trying to get his attention. I have never personally had any experiences in here, but I can never resist a good story.

CHAPTER 6
SOLDIERS' AND SAILORS' MONUMENT

The Soldiers' and Sailors' Monument is located at 3 Public Square in downtown Cleveland. This amazing monument was erected to celebrate the service of the soldiers from Cuyahoga County during the Civil War. The memorial room is located at the base of a 125-foot column with the Goddess of Freedom located atop it. The monument was designed—as were the busts, the interior bronze reliefs and exterior statues—by Captain Levi Scofield.

Captain Scofield only agreed to take on this project on the grounds that he received no monetary compensation for his work. There was much debate about where this monument should be located, and many politicians felt that Public Square was not the place for it. Even though the site was decided, there was still resistance, so in the beginning, every time Levi Scofield showed up to work on the monument, local politicians had him arrested. Finally, there was such a public outcry about the holdups that work was allowed to continue with no more interruptions.

Captain Scofield created an unusual monument. It was not meant to glorify war but rather to glorify the service of these men and women. There are many design choices that truly make this one of a kind. The four statues outside circling the memorial room depict scenes of war and represent the four branches of the Union army, the navy, the cavalry and the infantry and artillery. In his sculptures, Captain Scofield not only showed African American and Caucasian soldiers working together on a ship (this was unheard of, but there could be no segregation on a ship), but he also

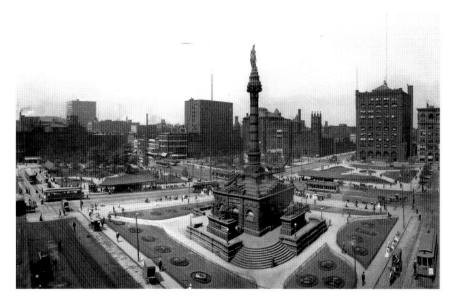

An older photograph of the Soldiers' and Sailors' Monument located at Public Square. *Courtesy of Soldiers' and Sailors' Monument.*

showed the escalation of war with soldiers shown injured and dying. The sacrifice and service of the animals, particularly the horses and mules, was also shown, and the horse on the fourth statue is shown falling in battle. There is also a depiction of the Confederate flag to represent all of the soldiers' service. Again, this was to show the ugliness of war and celebrate the service of the people.

The bronze reliefs inside show the Soldiers Aid Society, The Emancipation of Slaves, Beginning of the War in Ohio and The End of the War. This is where Captain Scofield also made an interesting design choice by including the Soldiers Aid Society, which is the first relief that you see as you enter the monument room. It gives people a glimpse of the contribution that women made to the war effort. The women immortalized here raised more money for the war effort than anyone.

The statue on top of the 125-foot column, the Goddess of Freedom, is a woman wielding a sword. Captain Scofield used his wife, Elizabeth, as a model for the goddess. She is portrayed wearing Scofield's own frock coat, his belt, boots and carrying his sword.

But the main focus of the memorial room is the marble tablets running around the interior. These tablets list the name and regiment of every soldier who served in the Civil War who came from Cuyahoga County or fought

with Cuyahoga County regiments. It is truly an awe-inspiring sight. The gentlemen who work here have found additional names to add to the wall through research and dedication. In order for a name to be put on the wall, that soldier's paperwork must be in order, meaning that the monument historians must have the soldier's muster in and muster out dates. And sometimes that is difficult to establish because as the war was coming to an end, paperwork got a little sloppy, but these men have done the research and added many, many men to the wall.

The stained-glass windows in the monument are unique, as they have a military subject matter, and it is believed they were done by a Tiffany-trained stained glass maker, even though they are not signed.

In 2010, a complete restoration was done of the monument to bring it back to its original beauty. All the original colorization was redone, the stained glass was cleaned and re-leaded and all the original lighting fixtures were rewired, making Soldiers' and Sailors' Monument a jewel in downtown Cleveland.

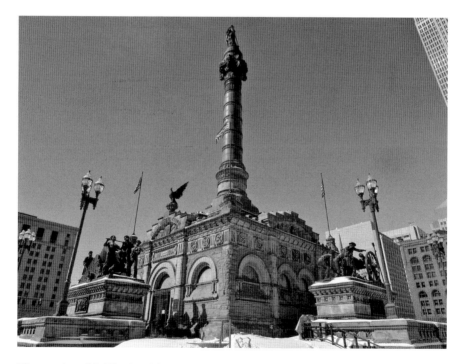

The exterior of Soldiers' and Sailors' Monument, present day. *Courtesy of Beth A. Richards.*

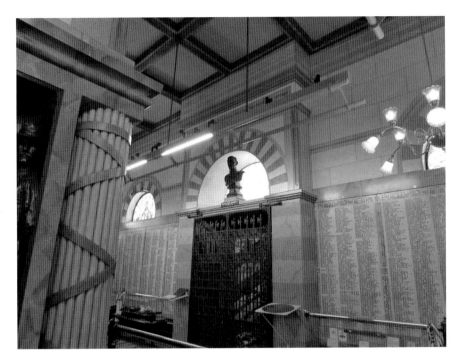

A photograph of the interior of the Soldiers' and Sailors' Monument, present day. *Courtesy of Beth A. Richards.*

We were very excited to begin using this stop on our tour, because even without the ghosts, the gentlemen who work here, Tim Daley and Tim Leslie, and the volunteers truly bring history alive for our guests. It is amazing that every time we bring a new group in, we have Clevelanders say, "Wow, I work down here and never knew you could come inside or even that there was an inside!" It is gratifying to show people such an amazing place for the first time. Our usual guide, Tim Leslie, shares the history of the monument with our guests but also goes one step further. He takes them on a tour of the tunnels that snake underneath Public Square. It is a truly wonderful experience for our guests, and it has become so popular that once a year the monument opens up and does a special tunnel tour for everyone. Tim escorts them down into the tunnels, which are reached by an almost invisible staircase inside the monument, and these tunnels curl around underneath the monument and go out to the street. These tunnels were originally used for the storage of uniforms and extra munitions, but now they seem to hold something else.

Tim Leslie has had many experiences in the tunnels and in the monument itself. One day when he was working, a gentleman came in to view the monument and started up a conversation with Tim. He informed Tim that he was a veteran who had been injured in Vietnam. As a result of the injury, he had a metal plate put in his head, and ever since that time, he has been able to see spirits. He told Tim there was the spirit of a man in full Civil War uniform standing just inside the front door, pacing back and forth, as if he were on patrol. The man told Tim that the spirit just wanted to protect the monument and all who visited, and he meant no harm.

Tim also had an experience with a woman who came to visit; she claimed to be a psychic and told Tim that she felt a lot of energy in the building. She asked him if it would be possible to go into the tunnels, and since it was a slow day, Tim escorted her downstairs. When they got down there, she looked at Tim and said, "There used to be a set of lockers here," which Tim confirmed. She said that there was a gentleman down there who used to work in the monument and was wondering where his locker went, and she went on to describe the fellow. Tim was surprised because the description matched that of a previous worker who had passed away, but what surprised him more was that the woman had broken into a heavy sweat—I mean, literally drenched. Worried something was wrong with her, he escorted her back upstairs, but by the time they got upstairs, she was completely dry.

The monument has begun to allow ghost hunting groups to investigate, and one group came in and began to do an EVP (electronic voice phenomenon) session in the tunnels. People often use digital recorders to ask spirits questions and see if they can pick up any answers the spirits may have. Tim escorted the group into the tunnels, so he was at the head of the line, and he asked, "Is there anyone here who wants to talk with us?" The group continued their session and kept exploring and then went up to analyze their recordings. When they listened to the recording, they heard a woman's voice saying, "They are coming. They are here." Before Tim even asked if anyone wanted to talk—if that didn't give you goose bumps—they then heard as clear as a bell a woman's voice saying, "I am Carrie." What is even more amazing is when you look at the Soldiers Aid Society relief; the third name from the bottom is Carrie Grant. She was a woman who helped in the war effort. Ready to stop and visit the Soldiers' and Sailors' Monument yet? Well, we aren't done with the stories.

We have had many guests download a ghost app to their phones, and these apps really just speak out words. One time we had a lady who downloaded the app, and when she walked in the monument, her phone immediately

said the name Elizabeth—interesting since Captain Scofield's wife's name, whom the Goddess of Freedom is modeled after, is Elizabeth.

There have been many interesting photos taken on our tours down in the tunnels. In one, you can clearly see a soldier in full uniform. Perhaps he is the gentleman who guards the door.

In another photo that a guest took, you can see a very large orb, and when you zoom in on the orb, it is the face of a bearded man. If you look at the bust above the door, you will see the orb strongly resembles Captain Levi Scofield. I like to think that Captain Scofield likes to stay here and keeps an eye on his magnificent monument.

On one tour, we arrived with the group, and Tim looked distinctly out of sorts. I was worried something was wrong and asked if he was all right. He told me that he had been down in the tunnels before we got there, just making sure everything was okay, when he felt something grab his arm and then his arm started to sting. He thought he had something in his shirt that was scratching him, so he came upstairs and pulled his sleeve up to see what was rubbing. When he pulled his sleeve up, there was nothing there except for three scratches on his arm. He said it was the only time he ever felt uncomfortable being in the monument by himself. Tim said he didn't feel that anything or anyone was trying to hurt him, just trying to get his attention.

On one tour of Soldiers' and Sailors', we had an interesting experience, and it didn't happen in the tunnels—it happened in the memorial room. We generally have to split our group into two separate groups to tour the tunnels because it is a close space, so I entertain the group of guests who are left upstairs. They are free to explore the memorial room or walk outside to take a closer look at the statues, but there was one woman who had gone to the back of the room and she was out of my line of vision. When it came time for the second group to go down into the tunnels, I did a quick search, and she was walking up to join the line. She turned to me and asked, "Did you hire the nice young man in uniform to tell stories also?" I could only stare at her with my mouth gaping open, and eventually I was able to stutter, "No. No, we didn't hire anyone in uniform to tell stories." I must admit she kept her composure, but she stepped out of line and said she didn't think she would go in the tunnels; she thought maybe she would just go wait on the bus. I couldn't really blame her.

On the tour, people always ask, "Well, who died here? What can be haunting it?" Although there is a legend that a previous caretaker died in the monument, I have never found proof of it, so I have to say, "No one

to my knowledge died here." So then they say, "How can there be ghosts here?" I must say that I puzzled over this. So one day Tim and I were talking, and he said that he felt it could be one of two things. One is that there is personal memorabilia in the monument, and perhaps some spirits attached themselves to the mementos. Or maybe, because the monument is such a testament to service, perhaps these brave soldiers have found their way to the monument for the peace it offers them.

Soldiers' and Sailors' Monument is an amazing place nestled in downtown Cleveland, so do yourself a favor and stop in and visit Tim Daley, Tim Leslie and the other volunteers and see a wonderful piece of history and maybe a spirit or two.

The monument is open Tuesday through Saturday, 10:00 a.m. to 6:00 p.m., and admission is free.

USS *COD*

The USS *Cod* is a submarine and museum located on the shores of Lake Erie by the East Ninth Street exit on North Marginal Road. The *Cod* is also on the National Historic Register. It was launched on March 21, 1943, and commissioned on June 21, 1943. The USS *Cod* was used to combat the enemy in the South Pacific; it made seven successful patrols with a total of 415 patrol days before the war was over. It is the only sub on display that uses the original stairways and hatches; there have not been any changes made to the structure.

Cleveland gets partial credit as the *Cod's* birthplace since the five massive diesel engines aboard it were built by the General Motors diesel plant that was on Cleveland's west side.

The *Cod* operated from Australian ports during World War II and received a battle star for each of its seven war patrols, and its skippers claimed ten ships sank and five damaged by torpedo.

On its seventh and final patrol, the *Cod* made a unique name for itself. On July 8, 1945, the *Cod* came to the aid of a Dutch submarine, the *O-19*, which ran aground in enemy waters. The crew of the *Cod* attempted to tow the Dutch submarine off the reef for two days before they realized it was a lost cause. The only way to save the Dutch submariners was to take them onboard the *Cod*. So the 56 sailors joined the crew of the *Cod*, and for the next three days while they made their way to safety, the *Cod* was home to 153 men. Talk about tight quarters. This is the only international sub-to-sub rescue in history.

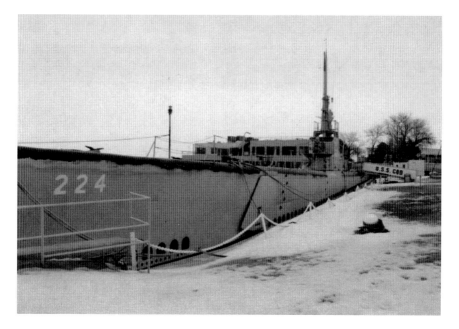

The USS *Cod* docked at its permanent home. *Courtesy of Chuck L. Gove.*

After delivering the *O-19* crew to safety, the *Cod* returned to its patrol area off the coast of Vietnam sinking junks that were carrying enemy supplies. During one of these operations, a five-man boarding party was stranded, and it took several hours before they could surface to try to find their boarding party. It took two days before the lost crewmen could be found, thanks to the submarine *Blenny*.

On August 13, 1945, the *Cod* returned to Perth, Australia, and was met at the dock by the crew of the *O-19* who invited them to a thank-you party for their rescue. Today the *Cod* carries a cocktail glass on its battle flag and its conning tower to commemorate the rescue and the party. The crew of the *Cod* were made honorary members of the Dutch navy, and this allows them to fly the Dutch flag. The surrender of the Japanese was announced during this celebration.

In 1951, the *Cod* was recommissioned to help train NATO antisubmarine forces during the Cold War and was credited with sinking an aircraft carrier in 1952.

In 1959, the *Cod* was towed to Cleveland as a training vessel, and by 1971, it was headed to the scrap yard until a campaign was started by the Cleveland Coordinating Committee for COD, Inc. to save it as a memorial

and museum. In January 1976, the navy gave the *Cod* to its civilian caretakers. In 1986, it was designated as a National Historic Landmark.

There was only one wartime casualty aboard the *Cod*: Andrew G. Johnson. In April 1945, the *Cod* was preparing to leave for its sixth patrol in enemy waters, and one of the crew members was extremely nervous to be going underway, not because of the enemy but because he believed he suffered from a family curse. Johnson told some of his buddies that his family was cursed and he didn't want to jinx the whole crew. He went on to say that his grandfather died before his twenty-seventh birthday, his father died right before his twenty-seventh birthday and his own twenty-seventh birthday would be in June during this journey. Andrew Johnson felt if he could make it past his twenty-seventh birthday, the curse would be lifted, and he would be lucky for the crew of the *Cod*.

On the night of April 27, 1945, the *Cod* suffered a near tragedy that almost sank it. The torpedoes that were aboard were powered by electric batteries that needed to be charged from time to time, but on the night of April 27, one of the sailors ignored his training and didn't charge the batteries. One of the torpedoes suffered an electrical short, and a fire started inside it. If the fire were to ignite the warhead, the sub would surely sink, causing almost certain massive human casualties. The first two sailors on the scene were Larry Fully and Andrew Johnson. Johnson and Fully went topside to try to open the torpedo hatch from outside so the smoke wouldn't contaminate the sub. Larry Fully grabbed a life jacket on his way up, but because the water was so rough, they were unable to open the hatch. Fortunately, two of the other submariners were able to get the torpedo into the tubes and fire it off the sub, saving the crew.

A large wave came and washed both Jackson and Fully overboard and out to sea. The crew of the *Cod* searched all night, and finally at dawn, just before the captain was ready to give the order to dive, they spotted Larry Fully. The life jacket he had grabbed saved his life. He told his rescuers that he had managed to hold onto Andrew Johnson until a wave pulled them apart, and before Fully could reach him again, he had sunk into the depths. The truth was Andrew Johnson was not a very strong swimmer; he had wanted to be in the navy so badly that he had someone else take his swimming test. So Andrew Johnson did fall to the family curse and lost his life before he was twenty-seven years old, but when his sister came to tour the *Cod* after it was restored, she informed the crew that the curse ended with him. She said none of her other siblings died before their twenty-seventh birthday.

The tower of the USS *Cod* bearing the *Cod*'s wartime victory tallies, present day. *Courtesy of Joel Craig.*

During World War II, U.S. submarines sank more than 55 percent of the ships that the Japanese lost; this includes 70 percent of its merchant ships and more than 220 warships. These submarines conducted intelligence-gathering missions and rescued more than 550 aviators who were forced into enemy seas.

The caretakers of the *Cod* feel that Andrew Johnson's spirit continues to watch over the *Cod* and its crew. There have been numerous reports from members of the *Cod*'s crew of footsteps being heard above deck when they were below. Lights were turning off and on and bells were ringing in one area of the sub when they are in another, usually alerting them to visitors or something else that needs their attention. Even in death, Andrew Johnson tries to take care of the USS *Cod*.

The *Cod* is maintained as a memorial to the more than 3,900 submariners who lost their lives during the one-hundred-year history of the United States Navy Submarine Force.

We have been privileged to visit the *Cod* many times over the years, and although I have never had any personal experiences, many guests have reported feeling a presence with them as they toured the sub. On one tour, we did have one guest who felt rather uneasy about going down to explore

below decks. I have always been very careful to warn people that if they are in anyway claustrophobic, they may not want to go down the hatch. The guest assured me that close spaces did not bother her, so I sent her on her way down. When she came out the other side, I was waiting for her, just to make sure she was all right. When she came up the ladder, she was near tears. I asked her what was wrong, and she told me that she felt such fear and sorrow while she was going through the sub. Perhaps Andrew Johnson was feeling fear and sorrow over the tragic accident that took his life, and she just picked up on the feeling. By the time she walked off the *Cod*, she seemed to feel much better, but she said she was amazed by how much she was affected by the atmosphere inside the sub. There have been strange shadows in photos, but the lighting below deck is not perfect for photography. Do we have proof that Andrew Johnson walks the deck of his sub, taking care of the caretakers and all who visit? No, but I certainly like to think so, don't you?

The *Cod* is open for tours May 1 through September 30.

CHAPTER 8

ERIE STREET CEMETERY

L ocated in the heart of downtown Cleveland, across the street from Progressive Field, Erie Street Cemetery is the oldest existing cemetery in Cleveland. It is very quiet and peaceful in the cemetery even though it is surrounded by the hustle and bustle of downtown.

The gate, which is located on East Ninth Street, is a beautiful example of Gothic architecture. The gate cost over $8,000 when it was first built in 1861. The stone fence around the cemetery was built to address concerns over the condition of the cemetery. The Works Projects Administration (WPA) built this with sandstone that came from the Superior Avenue viaduct after it was demolished. Erie Street Cemetery is on the National Historic Register. It was established in 1826, and the earliest internment was Minerva White in September 1827, although some older residents were reinterred here. Erie Street Cemetery actually has over seventeen thousand burials, although many of the stones have been lost, either from age or vandalism.

As you enter the cemetery from East Ninth Street, to the left is the final resting place of the Lorenzo Carter family, the first settlers of Cleveland, and on the right there are some of the victims of the *Griffith* steamship disaster of 1850, although the grave is not easily found. The *Griffith* was a steamship that was built in 1848. When it left Buffalo on June 16, 1850, for its inaugural journey, the *Griffith* carried over 300 passengers and cargo. On June 17, 1850, fire broke out aboard the ship near the smokestacks, and the wind pushed the fire toward the stern, where the lifeboats were. The captain tried to beach the ship to save lives, but the ship ran aground on a

The Gothic-styled gate of Erie Street Cemetery, located at the Ninth Street entrance. *Courtesy of Cleveland Public Library Photograph Collection.*

sandbar around 220 feet from shore. The fire grew, and many passengers went overboard as their only hope for survival. Unfortunately, few of these people knew how to swim, so this is still considered the largest loss of life on Lake Erie. Bodies washed ashore and were buried in a mass grave. Later, a number of these people were reinterred in Erie Street Cemetery.

Among those interred here are 168 veterans of various wars, starting with the Revolutionary War, Spanish-American War, the War of 1812 and the Civil War. One of these men is General James Barnett. He was a Civil War veteran who was also involved in the commission of the Soldiers' and Sailors' Monument and a member of the Cleveland Grays. Another veteran is Gamaliel Fenton. He served in the Revolutionary War and the War of 1812. Fenton has a new grave marker with a reproduction of *The Spirit of '76*.

Another interesting inhabitant of Erie Street Cemetery is Alfred Williams (1889–1900). Alfred was an orphan brought to Cleveland from Pennsylvania.

He worked as a newsboy until he was found dead, a suspected suicide. When Clevelanders heard about this tragedy, they offered to help provide him a proper burial, but his fellow newsboys wanted to do this for their friend, so they pulled their money together and bought him a plot. The owner of a monument company later donated a monument for him. The monument depicted a marble newsboy holding newspapers. Inscribed on the monument was, "He was a newsboy without father, mother or home and was buried by his newsboy comrades." Alfred's grave was in the corner of the cemetery by East Fourteenth Street, but the monument has disappeared, either by vandalism or perhaps it simply sank into the earth.

The original planners of the cemetery envisioned the 8.8 acres to be broken up into many avenues, but today only the center road is visible. As you walk the tree-lined avenue, you will still see many magnificent monuments. The Case monument stands tall in homage to Leonard Case Sr., who sold the land to the Cleveland Village trustees for one dollar so Erie Street Cemetery could be built.

During the 1920s, there were rumors that the cemetery housed many undesirables, such as thieves and drug dealers. It is said that behind one of the old vaults, dealers of opium and cocaine did their business.

The main avenue of Erie Street Cemetery. *Courtesy of Chuck L. Gove.*

Grave robbers once broke into a vault belonging to former mayor Josiah Harris to steal a large diamond ring it was rumored that he had been buried with. To their surprise and horror, they unwittingly opened the casket belonging to Mr. Harris's mother, who had been deceased for many years. They left empty-handed.

There was a chapel located in the center of the cemetery, but unfortunately it had to be torn down in 1954 due to neglect.

The cemetery served Cleveland for many years, but in 1904, Highland Cemetery opened, and Cleveland's mayor at the time felt Erie Street Cemetery was no longer a prime burial site, so several grave sites were moved. Public outcry was so great that the city manager was convinced to build the Hope Memorial Bridge around the cemetery, and Erie Street was rededicated in 1940.

As you walk farther down into the cemetery, on the right-hand side is the grave of Chief Joc-O-Sot, a Sauk chief who fought in the 1832 Black Hawk War, in which he was injured. He came to Cleveland and worked as a hunting and fishing guide and then became part of a vaudeville troupe called the Dan Marble Theatrical Group. The troupe toured the United States and Europe and was received by Queen Victoria in 1844; it is rumored that Queen Victoria even commissioned a portrait of Joc-O-Sot.

As a result of an old bullet wound, Joc-O-Sot became ill at the end of the tour. He tried to return to Cleveland to see an old friend, Dr. Horace Ackley, but he did not make it. He died at the age of thirty-four on September 3, 1844. Chief Joc-O-Sot has two gravestones in Erie Street. The first one, his original stone, has fallen over and shattered, and the second one was erected later. There is a legend that Joc-O-Sot was so angry that he was not able to be laid to rest with his forefathers that he shattered the first marker and wanders the cemetery because he is not at peace.

Next to Chief Joc-O-Sot lies Chief Thunderwater. Thunderwater (1865–1950) was a Native American who was very active in Cleveland's affairs and was a spokesman for the role his tribe played in the settlement of the Western Reserve. He was a part of Buffalo Bill's Wild West Show and toured all over the country. He remained a Cleveland celebrity throughout his life. It is said that Chief Thunderwater practiced many rituals to try to bring Chief Joc-O-Sot's spirit the peace it needed, but no matter what he did, Joc-O-Sot still does not rest easy. He has been sighted many times by many different visitors.

There are also reports of a ghostly woman in white appearing around the gatehouse of the cemetery. Her identity has never been revealed to

The original grave marker of Chief Joc-O-Sot. Legend claims his spirit shattered it to show his displeasure over his final resting place. *Courtesy of Cleveland Public Library Photograph Collection.*

Chief Joc-O-Sot's new grave marker. *Courtesy of Chuck L. Gove.*

anyone, but we have had guests get pictures from time to time with a figure that could have possibly been that of a woman in a white dress. I used to joke on tours that it is always a woman in white—why doesn't she ever wear red or any other color? And then I did some more research; in earlier times, women were often buried in their best clothing, which was typically their wedding dress.

We have used Erie Street Cemetery on many occasions for our tours. The history of the cemetery and its location seem to be of great interest to our guests, and it truly is a great place to end a ghost tour.

We usually set our guests loose with dowsing rods to do a little ghost hunting of their own and have found that for a lot of people, when their dowsing rods are active and a picture is taken of their hands, there is an orb above their hands. However, on one occasion, we actually had a face appear behind a woman.

On one of our earlier tours, we had a young lady take a set of dowsing rods to use in the cemetery, and as she was walking with them, the copper rods actually bent backward toward her. I had never seen that happen before, and I must say it made me a little nervous. We gave her another set, and this set did the same thing, so either a spirit wanted to give her a very important message or she just has a magnetic personality.

Another popular thing our guests have been doing is downloading a ghost app to their phones. We had one guest do this on a day tour, and when the app started to talk, it said, "Lizzy, Lizzy." She happened to be standing by a headstone, and the only legible thing on the stone was the name Elizabeth.

Erie Street Cemetery is a very peaceful place to while away some time, but visitors should know that there is a sign stating that the cemetery closes at 6:00 p.m.

CHAPTER 9
THE CLEVELAND POLICE MUSEUM

The Cleveland Police Museum is located at 1300 Ontario Street, inside the Justice Center, in the middle of downtown Cleveland. It is the brainchild of Detective Robert Bolton, who came up with it after a visit to Scotland Yard's Black Museum in London.

In May 1983, the Cleveland Police Historical Society was born, and the museum opened in June that same year. It started out as a 1,200-square-foot museum and has grown to approximately 4,000 feet of exhibits, offices and storage of artifacts. The Cleveland Police Museum is unique in that it works together with the Cleveland Police Department, not under its control. In its years of operation, the museum has had visitors from all over the world.

The museum has amazing collections and some very unique artifacts, including some of the death masks of victims of Cleveland's most infamous unsolved murder case, the Kingsbury Run, or the Torso Murders, which started in September 1935 and continued for three years. These masks were created to assist the police in identifying these victims, the majority of whom, as well as the killer, have not been identified to this day. The museum is very lucky to have one of the foremost experts on the Torso Murders, Dr. James Jessen Badal, as a trustee of the museum. He has been wonderful on our tours, discussing all the theories behind these murders with our guests.

The museum also has a great collection pertaining to the time that Eliot Ness spent in Cleveland as the city's safety director. It has also collected a great many artifacts connected to Cleveland's history. Haunted Cleveland has been extremely grateful to President Tom Armelli, Bob Cermac and

The death masks of some of the victims of the Torso Murderer, Cleveland's first serial killer. *Courtesy of Chuck L. Gove.*

Doctor Badal for their knowledge and willingness to share this great museum with our guests.

But what the museum really does is honor the law enforcement that has kept the city safe for the past 150 years. The Cleveland Police believe Moses Cleaveland to be the city's first peace officer, as he was the one to assure peace and safety to the first settlers. But when he left, the job went to Lorenzo Carter, who was the city's first permanent settler and who became the city's first constable. One of Carter's first acts was to track the murderers of two fur trappers near Sandusky. They were caught, and one of them was found guilty and sentenced to death by hanging. O'Mic was hanged in Public Square, and his was the first public execution in Cleveland. O'Mic's execution ended with a terrible storm. Thunder and lightning rained down, so the legend says, and in the confusion, the corpse of O'Mic disappeared. It was later determined that his corpse was stolen by some doctors to study. After that, all executions were held in the courtyard of the county jail, and people could attend only by invitation of the sheriff. In 1888, the state decided that all executions would be held in Columbus, but the Cleveland Police had the original hangman's noose and gallows until the early 1900s. In 1897, the first execution was held in the electric chair.

Now, all this history is great, but I am telling it for a reason. The museum never had any paranormal activity until in 2012, when it introduced a new exhibit entitled "Capital Punishment in Cuyahoga County." The exhibit told the history of capital punishment, with the stories of nine men tried and convicted of murder and sentenced to death by hanging,

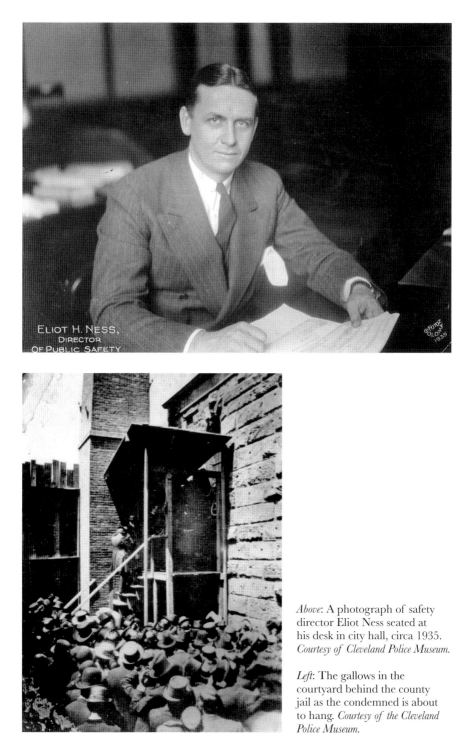

Above: A photograph of safety director Eliot Ness seated at his desk in city hall, circa 1935. *Courtesy of Cleveland Police Museum.*

Left: The gallows in the courtyard behind the county jail as the condemned is about to hang. *Courtesy of the Cleveland Police Museum.*

Left: A ticket to be admitted to an execution, given out by the sheriff. *Courtesy of the Cleveland Police Museum.*

Below: Photo of the jail cell on permanent display at the Cleveland Police Museum. It was taken out of Central Station on Payne Avenue. This cell was on the women's side of the jail. It was in service from 1925 until 1977. *Courtesy of the Cleveland Police Museum.*

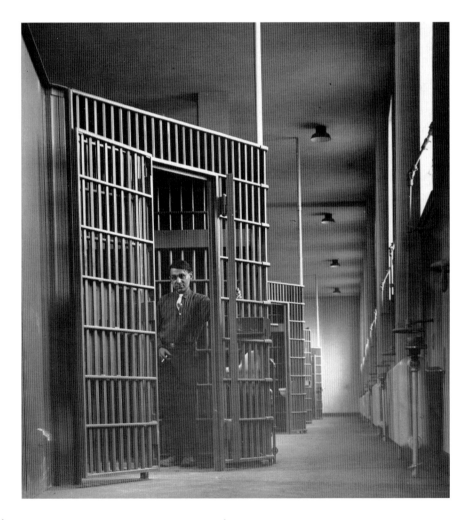

and the history of the electric chair, for which it brought in the only electric chair ever used in the state of Ohio. It was on loan from the Ohio Historical Society, the same chair in which 315 men, women and children (seventeen-year-old William Haas was the first person executed in this chair) were executed.

The museum brought the chair in, installed it in its display area and covered it up, but in the two weeks before the exhibit opened, some staff members claimed its presence made them uneasy. The exhibit opened, and the staff got used to the chair being there, but it seemed to stir up something in the museum.

One afternoon, the president of the museum, Tom, was there talking to someone in the office, and he noticed a lone guest enjoying the exhibits. As she approached the jail cell that is on permanent display, the woman fainted dead away. She was only out for a few seconds before Tom got to her and she was already coming around. The staff got her up and steady, and Tom asked her what had happened. She said that the woman sitting in the cell had taken her by surprise since she thought she was the only visitor to the museum. They asked her to describe the woman, and the best she could give them was middle-aged, in a long gray skirt or dress. The poor woman asked where the woman had gone, and the staff kind of ignored the question because they hadn't seen anyone else in the museum.

A few weeks went by, and a group of senior citizens came in the museum on a self-guided tour. Two of them went up to a staff member and said that there was a woman locked inside the jail cell. The middle-aged woman in a long gray dress was not a member of their group. The staff member was pretty surprised because the jail cell is always kept open so no guests smash their fingers, but when she walked over to the cell, it was locked. No one was inside, but it was closed and locked.

Right before the exhibit was getting ready to close and be taken down, a group of kids were in the museum. They seemed pretty interested in the electric chair and the whole exhibit. One of the kids walked back to the gift shop and said to the one employee that there was a woman inside the fenced area by the electric chair. He said it was cool and asked it they could go in also. The staff member was shocked. She quickly made her way over to the exhibit, and the kids were all standing there staring at nothing. There was no woman by the chair. The kids left rather quickly, and the woman checked the lock on the gate. It was locked, but upon closer inspection, the employee saw that there was a pattern on the seat of the chair, as if someone had been sitting there and disturbed the dust on the seat.

A retired attorney stopped in the museum one day. He had business in the courts and always dropped by if he was in the area, and on this day, he went over to see the capital punishment exhibit. He quickly walked back over to the person working and said, "Excuse me. There's a man sitting in the electric chair. Is anyone supposed to be there?" When the employee got over there, again the chair was empty.

As the employees began to take down the exhibit, they were checking over the chair, and stuck to one of the legs was a piece of gray material. No one can swear that it wasn't on the chair when it arrived, but if not, who did it belong to—the middle-aged lady or the man who was spotted in the chair?

The electric chair on display at the Cleveland Police Museum. This is the only electric chair that has been used in the state of Ohio. *Courtesy of the Cleveland Police Museum.*

The staff of the museum only connected all these incidents after the electric chair left the building. They were all sitting around talking, and that's when it all came together. The only unanswered question was the woman in the jail cell, and then they realized that the cell had come from the women's section of the old Central Police Station, so that explained the mysterious woman. The man seen sitting in the chair, well, maybe he was one of the folks who lost his life in the chair and his spirit was still attached somehow. Of course, no one knows for certain who or what these people were, but they do know that nothing strange has happened in the museum since the electric chair left.

The Cleveland Police Museum is open Monday through Friday, 10:00 a.m. until 4:00 p.m., and admission is free.

PLAYHOUSE SQUARE

Built in the 1920s, Playhouse Square has once again become a major player in the renaissance of downtown Cleveland. Spreading over several city blocks, Playhouse Square is the second largest theater district in the country. Playhouse Square has also installed the world's largest outdoor chandelier to further showcase this wonderful complex.

The first two theaters, the Ohio and the State, were designed by Thomas Lamb, and they opened in February 1921. Their glittering marquees are on Euclid Avenue. The Hanna Theater, on East Fourteenth Street but still a part of Playhouse Square, opened in March 1921. The Allen Theater, located in the Bulkley Building, opened in April 1921 as the Allen Movie House. And last but not least, the Palace Theater opened in 1922, mostly as a vaudeville theater.

These magnificent theaters offered Clevelanders movies (both silent and talkies), the latest vaudeville acts and out-of-state plays and musicals. There was something for everyone at Playhouse Square. Each of these theaters is an architectural masterpiece, and the opulence and elegance of each blends together to create a stunning background for the arts.

But the Great Depression came, and people could no longer afford the theater. There was a brief revitalization during World War II with Americans flocking to see war movies and seeking escape in the popular musicals of the time. After the war, however, people began to stay at home; the birth of the television was the death knell of the theater. By 1969, all the theaters but the Hanna were closed. Vandals and fire took their toll,

An early photograph of the Playhouse Square theater marquees. *Courtesy of Cleveland Public Library Photographic Collection.*

and the theaters fell into a horrible state of disrepair. The city began to talk about tearing these marvels down, but an employee of the Cleveland Board of Education asked to use the theaters as a meeting place, and that was the spark that ignited the restoration of the theaters.

A group formed the Playhouse Square Association and began to raise money by sponsoring events and beginning a two-year run of *Jacques Brel Is Alive and Well and Living in Paris*. The production was put on in the lobby of the State Theater. By the end of the 1970s, the association had begun the work of bringing these theaters back to life, and by the late 1980s, the restoration was complete.

They are once again attracting first-class entertainment to Cleveland and lighting up Euclid Avenue with their marquees. The Hanna Theater has been renovated and become the home of the Great Lakes Shakespeare Festival.

Anytime you research ghost stories and legends, you can be sure that you will find a haunted theater. They say that spirits are attracted to energy and

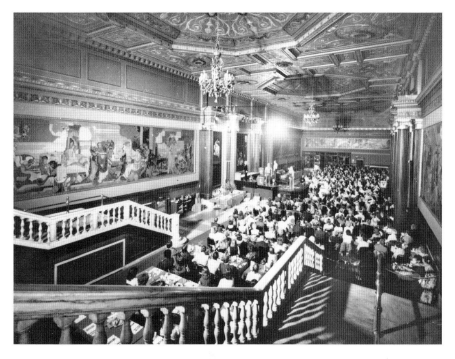

A performance of *Jacques Brel Is Alive and Well and Living in Paris* in the lobby of the State Theater. *Courtesy of the Cleveland Public Library Photograph Collection.*

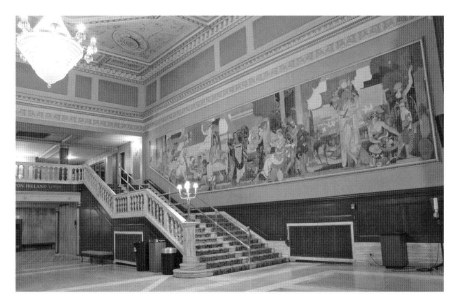

The lobby of the State Theater as it is today. On these steps is where a bride had an unwelcome visitor in her wedding photos. *Courtesy of Chuck L. Gove.*

emotion, and I can only imagine how much emotion—whether from the audience or performers, real or imaginary—there is in a theater during a performance.

We have used all the theaters at one time or another for tours, but the most activity and most photographic evidence has been found in the Palace Theater and the Hanna.

We were told a story by longtime employee Carol Lee Vella of her time at the Hanna. Carol Lee had heard the stories that a ghostly female patron walked the halls of the Hanna and that she was very active throughout the theater. Every morning, Carol Lee was the first to arrive at work, but to get to her office on the third floor, she had to turn on the house lights and cross the empty theater to put her lunch in the kitchen. And every morning when she put her key in the door, she said the very same thing, "Please don't appear to me today because I love my job, and if I see you, I will have to quit working here."

Carol Lee was lucky, and the female patron never appeared to her. But one day, she got a message from her.

A woman came in to set up group tickets for a performance, and Carol Lee was taking care of her. The woman asked, "Is there a ghost in this theater?"

Carol Lee responded, "Well, yes, that's what they say."

And the woman said, "And it's a woman, right?"

Carol Lee said, "That's what I have heard."

The woman went on to say, "Well, I am a psychic, and she is in the room with us right now, and she wants you to know that she spends a lot of time in here with you because she knows you love the theater more than anyone else in the office. To the rest of them, it's just a job, but you feel like she does about the theater." Carol Lee wasn't impressed; she had a lot of theater memorabilia scattered about her area, so she just smiled at the woman and nodded. Then the woman went on to say something that Carol Lee had never told a living soul. The psychic said, "She knows you are afraid of her, so she will never show herself to you. She doesn't want you to quit."

Carol Lee never in all her time in the theater ever saw the female patron, for which she was grateful.

Carol Lee seems to be the only person whom the female patron left alone. Staff in the Hanna reported that the lights would go on and off all the time. They would jokingly yell for the lady to leave the lights alone, and she would—for a little while, and then it would start all over again. This continued happening until they finally had to call in an electrician. The

electrician took one look at the electrical box and informed them that there was absolutely nothing wrong with the lights. He started to walk out, and the lady had a little bit of fun with him. She blinked the lights on and off as he departed. He ignored it and kept on going.

One night while touring the Hanna before its renovation, while I was telling the story of the female patron, a guest was taking pictures all around the theater, and in one of the photos there was a misty figure of a woman in what looked like a white dress. She didn't seem to mind our presence in the theater; as a matter of fact, I think she was happy that there was excitement and activity in her theater.

When Chuck works security, he is never sure where he will be assigned, but some years ago, the musical *Tony N' Tina's Wedding* started a run at the Hanna Theater, and he worked there quite frequently. This is a very high-energy show that is very interactive with the audience, and the actors embody that high energy level. Some of them were aware of Chuck's haunted side job and would play tricks on him and tell him it must be the female patron spirit in the theater. One night, he was working when someone—or something—reached out and grabbed him. He spun around to confront the prankster, but there was no one there.

All this joking around by the cast must have irritated the female patron because she began to raid the cast members' jewelry. She didn't take it; she knotted it all up. The ladies in the cast tried to hide the jewelry, but that didn't seem to matter to the lady. They would come in to get ready for the performance, and they would find their carefully hidden jewels all knotted up on their dressing tables.

The Palace seems to have a spirit that has been spotted many times. He is the man in green—he wears a green suit and bowler hat, and he moves throughout the theater. He has been spotted in the balcony—sometimes all of him, sometimes just his legs. He has been seen pacing backstage, and sometimes he actually makes an appearance on stage.

On many nights when I take the stage at the Palace to tell his story, people begin to take photos, and more times than not, there is a bright green orb behind me. The first time this happened, I was as startled as the young lady taking the picture, but as time goes on, I just think he wants to make sure I am actually giving him his due.

During another tour, I was standing in the aisle talking to a guest, and apparently I was in someone's way because I was suddenly shoved out of the aisle and into the seats. Someone took a photo, and you could see beyond me, standing by the exit, was a man in a suit. He seemed to

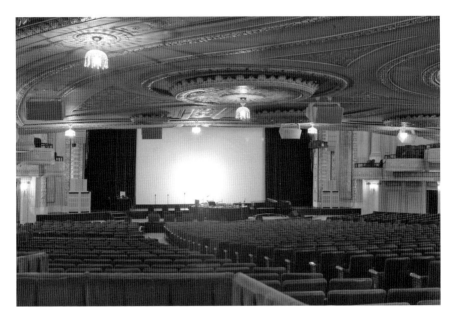

Inside the Palace Theater, looking at the stage where the man in the green hat appears, or at least his green orb. *Courtesy of Chuck L. Gove.*

be watching the guests exploring the theater. I must say that picture did creep me out a little bit.

On one tour last year, there was a large group who went upstairs to the balcony of the Palace to take pictures and investigate. All of a sudden, I heard a scream, and a woman rushed down the stairs. She told me that she had walked away from the group when she felt a hand on her shoulder. Thinking it was someone in her group, she turned around only to discover she was still completely alone—hence the scream. Maybe the man in the green hat had left the stage and wanted to get her attention.

On another tour last year, we took a day group to the Palace, and again I took to the stage to tell the stories of the theater and the man in the green hat when I heard a gasp in the audience. I figured I knew what was coming, but I was wrong. One of our guests did have a green orb on her picture, and it was on the stage, but in every shot after that, it seemed to be moving off the stage and coming closer to the group. It almost seemed to be following her through the theater, and this seemed to freak her out just a little bit. I, on the other hand, was just happy it wasn't following me.

Over the years, several women have come back from the restroom and reported that on their way down to the restroom they felt uneasy, as if

someone was behind them. There is apparently a nasty female spirit who seems to feel that the restroom is her domain and has reportedly pushed a couple ladies on the stairs.

The lobbies in all the theaters can be rented out for wedding photographs. On one occasion, the wedding party was assembling on the stairs, and the bride looked to the side to see a pair of legs standing next to her—just legs. Needless to say, the bride was a bit upset by the wedding photo crasher.

All theaters use what is called a ghost lamp. A ghost lamp is a light bulb on a pole lamp with a cage around the bulb, and it is usually put center stage. It is left on in the theater to illuminate the stage so the theater is never completely dark. Obviously, the practical reason is safety—the ghost lamp lights up the stage so technicians can get to the light board, and it prevents accidents. The ghost lamp is also referred to as an equity lamp, perhaps because it is mandated by the Actors' Equity Association.

There are many superstitions surrounding the use of ghost lamps. There is a belief by many that all theaters are home to at least one ghost, and people believe that the ghosts use the lamp to illuminate their own performances, which make them happy enough not to cause trouble in the theater. There are also many theaters that purposely leave open seats for any spirits that want to attend the performance. Theater people are a superstitious lot.

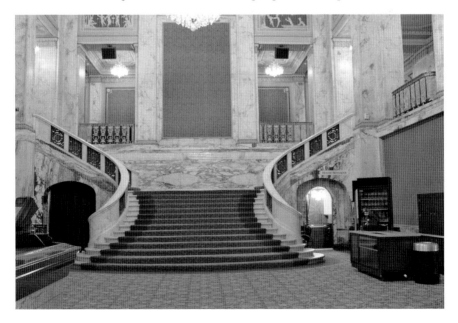

The stairway in the lobby of the Palace Theater. *Courtesy of Chuck L. Gove.*

The Playhouse is very diligent in its use of ghost lamps throughout the theaters. Whether for safety reasons or superstition, it is always comforting to see the glow of the ghost lamp when we walk into the theater. On one occasion when we were using the Palace for our tour, we walked in, and my eyes were immediately drawn to the stage. Something was wrong because the ghost lamp was not lit. The house lights were on in the theater, so I gingerly went onstage to tell our guests the history and haunting of the theater, but before I could start, I had to make sure that there was an actual physical reason that the ghost lamp was off rather than a supernatural one. I have never been so happy to find that something had been accidently unplugged. I have to admit that I did not relish the idea of telling the story of the man in the green hat without the protection of the ghost lamp. I guess I am just as superstitious as the next person, but I really didn't want to take the chance of upsetting the spirits of the Playhouse.

Located behind the State Theater at 1629 Dodge Court is a building that looks like it should be on the English countryside. This building is home to the country's oldest private club dedicated to amateur performing arts, the Hermit Club. The club was formed in 1904, and the first organizational meeting was held on March 12 of that year. There were fifty Clevelanders in attendance at the meeting held at the Hollenden Hotel who shared the ideals of what the founders wanted the club to have. This is when the name the Hermit Club was adopted. The first home of the Hermit Club was on the east side of Hickox Alley, which is now called East Third Street.

When the theaters opened on Playhouse Square, the Hermit Club pulled up stakes and moved over there also, right behind the State Theater. The current building was designed by architect Frank Meade, club founder and president of the club until 1937, and was designated a Cleveland Landmark in 1976. The Hermit Club has a long-standing tradition of music, classics to jazz, as well as stage performances, poetry readings and many other activities. Recently, the Hermit Club has entered into a partnership with Hofbrauhaus Cleveland and become a part of the Hofbrauhaus Cleveland Complex.

As everyone knows, theater people are superstitious. Most theaters have a ghost, and I think the country's oldest private club dedicated to amateur performing arts should have at least one ghost. The Hermit Club doesn't disappoint—it actually has two, and one of them is very unique, even in the spirit world. The club has a ghost rat that it has immortalized in a tiny bronze statue at the door. This rat was rumored to be someone's pet that passed over but apparently continued to haunt his owner at the club. Their

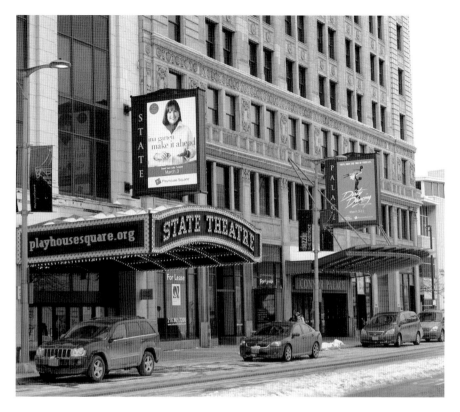

Modern-day view of the exterior of the Playhouse Square marquees. *Courtesy of Chuck L. Gove.*

second ghost is really more your run-of-the-mill ghost. This ghost seems to inhabit the kitchen, and staff and members affectionately refer to him as Hermy. Hermy has been known to be quite the trickster in the kitchen. Staff members report quite a bit of poltergeist-like activity, with pots and pans thrown to the floor, doors opening and closing and just general harassment of the kitchen staff and the chef. I wonder if Hermy has stayed at the Hermit Club or traveled over to the kitchen at the Hofbrauhaus.

CHAPTER 11

GRAYS ARMORY

The Cleveland Grays started life out as the Cleveland City Guards. Their purpose was to assist local law enforcement and be a first line of defense to the city. Their first meeting was held on August 28, 1837, and by September 18 of that same year, seventy-eight men had joined up. During that year, the membership decided that instead of being called the Cleveland City Guards, they would be known by the color of their uniforms and began to use the name the Cleveland Grays. Their uniforms are quite distinctive: a gray uniform with a very tall black bearskin hat. The Cleveland Grays' motto is *Semper Paratus*, Latin for "Always Ready." This signifies that they were always ready to serve and protect, whether it be their city or their country.

The Grays served in the Civil War and the Spanish-American War. Their last active service as a group was in World War I, although individual Grays have continued to serve in the armed forces.

The Cleveland Grays' first home was on the corner of Ontario Street and Prospect Avenue in downtown Cleveland. Then they moved in 1870 to a building on Frankfort Street that had formerly been a fire station. In March 1880, the Grays joined the Fifth Regiment and the Ohio National Guard in the City Armory on Long Street, but on December 8, 1892, a fire destroyed the wooden armory and its contents, including the guns that belonged to the Grays. Using a wooden building as the city's armory was probably not the best idea. The Grays immediately started a fundraising campaign, and they were able to raise the money fairly quickly to build a

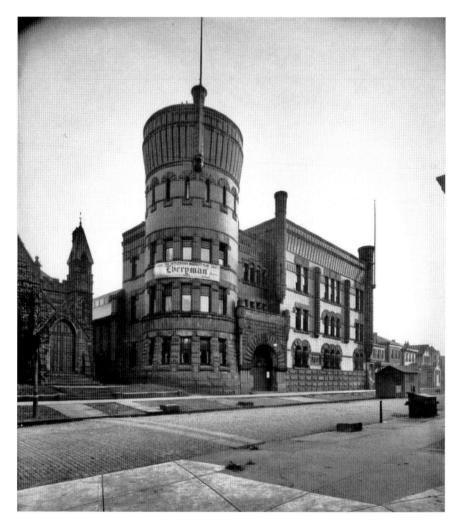

An old photograph of the exterior of Grays Armory. *Courtesy of Grays Armory Museum.*

new armory, but until construction could be completed, they settled in at the Gatling Gun Battery Armory.

The new armory built at 1234 Bolivar Road is a magnificent fortress. It was completed in May 1893. It is four stories high, with a five-story tower on the northeast corner. The main entrance has a black iron gate that drops down, and the first-floor windows have iron rods bolted to them—truly an impenetrable structure. It is constructed of sandstone, granite and red brick, and it looms, like a castle, over the street. There is a cornerstone placed in

front that has the dates of the Grays' inception and the completion of the armory. Inside the cornerstone, the commanding officer at the time placed the current roster of members, as well as Grays' mementos and newspapers. The massive building holds a drill hall, meeting rooms, a poolroom, a mess hall and, in the basement, there is a shooting range.

The armory was not just a place to hold drills and weapons. It was also a major part of the Cleveland social scene. The Cleveland Orchestra performed its first concert at the armory and played here frequently until it moved to Severance Hall. John Philip Sousa also performed here. The armory has an amazing organ in the drill hall, and organ concerts are still held here. The city's first car show and flower show were held here, along with many other social functions. Presidents Roosevelt, McKinley and possibly Taft were said to have played pool here.

The Grays have played a very important part in history, not only the history of Cleveland but also of the United States. They served as part of the guard when President Lincoln visited Cleveland in February 1861 and also were part of the honor guard when President Lincoln's funeral train came through Cleveland in 1865.

An interior shot of a second-floor meeting room in Grays Armory. *Courtesy of Brent Durkin.*

Nowadays, the Cleveland Grays are mostly a social organization seeking to promote patriotism and preserve the military history of Greater Cleveland. The Grays Armory Museum houses many military artifacts, including a full uniform of the Grays and a cannon. Throughout the building in the meeting rooms, there are more Grays artifacts, and upstairs there is a small ballroom and a reproduction mess hall set up. The Cleveland Grays still sponsor many events, including a Veterans Day event to honor all those who served.

There is an interesting story about the cannon that is in the museum. The Secesh cannon is a Confederate cannon that was captured by Cleveland troops during the Civil War. The commander gave the cannon to the Cleveland Unit, and when they came home, it was put on display at Camp Cleveland and was used to fire blank rounds to announce victories and, most importantly, the end of the war in 1865.

The cannon was moved to Public Square to stand on display by the Soldiers' and Sailors' Monument, and then it disappeared. It was relocated in a garage in East Cleveland, lost again and then found at the city dump. A Cleveland attorney gained possession of the cannon and, being a member of the 135th artillery himself (this unit being the one connected to the Cleveland Grays), felt that the armory museum was the proper place for the cannon. It was presented to the Grays in a ceremony in November 1961. It is now on display permanently on the ground floor of the museum and is believed to be the only captured Confederate cannon in existence in any major northern city.

There are many spirits attached to the armory, and one has made his presence known many times. The staff calls him Patrick, in honor of the many Irish workers who constructed the armory, and he is a bit mischievous. While the caretaker and crew were repainting the entryway, they had to put all the accent paint in little cups and climb up on scaffolding because they were working on the crown molding. This was very detailed and thirsty work for the crew, so they retired to the third floor for some refreshment. While they were sitting in the bar, they heard someone run up the stairs. They hadn't seen anyone run past the door, and they knew they were alone in the building, so it kind of freaked them out, and they ran down the stairs to investigate. When they got to the entryway, they discovered that someone or something had turned all the cups of paint over, and it had only just happened because the paint hadn't even had time to run off the scaffold. That pretty much finished their work for the night. Patrick has also been blamed for moving large potted plants around and moving flowers from one place to another. Apparently, he is quite the decorator.

One of the previous managers of the museum told us that sometimes she would bring her dog to work with her and keep him in her office. It is such an enormous space that she said he kept her company. She believes that he saw Patrick in the entryway many times. Her office was located right off the front hall, and she said that sometimes he would stand in the entryway staring at a table by the front door that held a vase with flowers, and he would just start to tremble and bark like crazy. When she would go out to yell at him to stop barking, he would turn and run into her office, and she would notice that the flowers would be moved to another table at the bottom of the stairs. If she tried to trick the spirit and put the flowers on the table that he favored, he would invariably move them back to the table by the front door. What a joker!

In one of the meeting rooms upstairs, an apparition of a young soldier has been seen by many people, and the apparition of an older soldier has been seen disappearing through the upstairs door that leads to the drill hall viewing balcony. There have also been stories of a woman in a long dress standing by the piano in one of the meeting rooms.

There have been numerous orbs caught in the upstairs ballroom, and people have claimed to have seen a man dematerialize through the wall between the ballroom and the mess hall. On one of our first tours in Grays Armory, Chuck's wife, Rita, came on the tour, and we were standing in the ballroom. She was leaning up against the wall where the soldier has been seen going through the wall just as the tour guide was telling the story, and the guide pointed to Rita and said, "That is right where people see him." Someone took a picture of Rita, and in the picture was a giant orb, standing right next to her. Funny, now that I think of it—it was years before Rita went on another tour with us, and that year we did not include Grays Armory.

One of the previous caretakers had two experiences with spirits here, and he didn't believe in ghosts. They both happened in the drill hall. The drill hall is a giant room, and the fire doors are located all the way in the rear. He was alone in the hall one day and saw one of the very heavy fire doors start to close. When he looked closer, he saw a hand—just a hand, with grayish green skin—pulling the door closed. He left the hall very quickly. After the hand incident, he was again walking across the hall, and he heard footsteps approaching him rapidly from behind. When he turned, he was quite alone, and when he started to walk again, so did whatever was following him.

Another caretaker reported a story about Major Lou Grosser. Major Grosser was in charge of Grays Armory for many years and suffered a

An interior photo of the second floor in Grays Armory. *Courtesy of Brent Durkin.*

massive heart attack in the drill hall. After he passed away, the caretaker and many others often smelled the vanilla pipe tobacco that Major Grosser favored in the drill hall. They all felt that Major Grosser was sticking around to make sure everything was done to his satisfaction.

We had a guest on one of the tours who really seemed to connect with the energy at Grays Armory. Our guide at the armory would usually stand on the steps to tell her stories and the history of the Grays so the whole group could see and hear her, and on this particular night, I noticed that one of the ladies on the tour was just staring at our guide—I mean, *really* staring. As we broke up to explore the drill hall, I caught up to her and asked her what was wrong. She told me that she saw a flash of a person standing behind the guide. I asked her what she meant by that, and she said that she thought she saw a man standing there, dressed in workingman's clothing, and then she blinked and he was gone. To me, it sounded like the spirit they call Patrick, but she said maybe it was just her imagination.

We continued upstairs, and I stayed pretty close to her in case something else happened. Let me tell you, I was not disappointed. We got to the second floor, and she was listening to the guide, and I noticed she was staring hard at the door that leads out to the viewing bleachers in the drill hall. She told me it had happened again, the flicker of a person, but this time she got the

sense it was an older man dressed in a uniform. For me, this night was getting better and better; for her, not so much.

By the time we made it to the third floor, I was almost beside myself, and again I was not disappointed. We got to the mess hall, and she seemed pretty relaxed, but when we moved into the upstairs ballroom, I heard her gasp and saw she had gone as white as a ghost (no pun intended). She seemed visibly upset and almost ill, so I walked over and asked her if she wanted to go outside, and she was very quick to say yes. By the time we got outside, she seemed to have calmed down, and so I asked her what she had seen. She told me that this time it was a younger man in uniform, and he walked through the ballroom and disappeared. I was almost giddy, but I really did try to hide it. I didn't want her to think I was a mean, evil person, rejoicing in her misery, but I couldn't wait to tell Chuck what she had seen. As a side note, when she called to make her reservations for the next year's tour, she was extremely happy and relieved to find out that Grays was off the list of stops for that year.

People have reported cold spots on the stairs and even spotted a soldier coming down the stairs. There was also a group of ghost hunters that came to Grays to do an investigation. As they settled in the drill hall, they were shocked when the ceiling fans all started moving in opposite directions. The more faint-hearted of the investigators quickly left the armory.

No one can say who these spirits are, but with a motto like *Semper Paratus* ("Always Ready"), apparently even death doesn't stop a Cleveland Gray from doing his duty.

The Grays Armory Museum is open to the public on the first Wednesday of every month from 12:00 p.m. to 4:00 p.m. Make some time to see some Cleveland military history, and maybe have a brush with some of the spirits of the armory.

CHAPTER 12

THE CLEVELAND AGORA

The Cleveland Agora is a legend in the music world. It first began in 1966 on Cornell Road in Little Italy and was the brainchild of Hank LoConti Sr., who recently passed away. The Agora moved to East Twenty-fourth Street in 1967. The venue was a showcase for up-and-coming stars, not only from the Cleveland area but international groups as well. Performing here were U2, Bruce Springsteen, Grand Funk Railroad and the Raspberries. It was the place to be seen. The Agora continued to expand, and in the 1970s, new locations sprang up all over the country, but the Cleveland location is the only one that still survives.

The Agora had to move in 1986 from the East Twenty-fourth Street location when fire destroyed the building, and it moved to its new location at 5000 Euclid Avenue. The building it now occupies has an amazing history of its own.

It started its life as the Metropolitan Theater and opened on March 31, 1913. The first show performed here was an English performance of *Aida*. The Metropolitan was conceived by Max Faetkenheuer, who was an opera promoter and conductor. He had been involved in the design and construction of the Hippodrome Theatre, which opened on Euclid Avenue five years earlier. The Metropolitan did well in the beginning but began to struggle financially. In 1927, it was the home to a Yiddish Theatre troupe, which lasted until 1928, when, while traveling to a performance, many were injured in a very serious traffic accident. Unable to perform, the company went bankrupt.

The exterior of the Agora as it looks today. *Courtesy of Chuck L. Gove.*

In 1932, the Metropolitan turned into a vaudeville and burlesque house called the Gayity. This was a very risqué time in its history.

In the mid-1940s, musicals were again produced and staged here, but by the 1950s it became a full-time movie house.

During the years from 1951 to 1978, the offices located upstairs became home to radio stations WHK and WMMS, and the theater was called the WHK Auditorium, which showcased such acts as Elvis and the Beatles. This is also the stage on which famous disc jockey Alan Freed first coined the term "rock and roll." In the 1970s, it was nicknamed the Disasterdome and featured new wave acts such as DEVO.

The early 1980s brought about changes again. The theater was called the New Hippodrome Theater and began to show movies again. Lucky for Cleveland, after the fire that destroyed the East Twenty-fourth Street

Agora, Hank LoConti moved into 5000 Euclid Avenue and began to do extensive renovations to keep the music scene in Cleveland alive. In December 2011, the LoConti family donated the Agora to Mid-Town Cleveland, a nonprofit organization. You can still see the grandeur of the old theater in the enormous lobby. There are two concert areas in the Agora Metropolitan Theater. One is a 500-person, standing-room-only ballroom, and the other is an 1,800-seat theater, complete with table seating and a balcony. The theater is still booking nationally acclaimed acts and is a force to be reckoned with in the music world.

But great music isn't the only thing that haunts the Agora. We have been lucky enough to use it many times on our tours, and one thing remains constant throughout the years: there is something out of this world there. Most ghost hunters believe that spirits can drain energy from batteries and sometimes even people. It is amazing how many video cameras, phones and cameras would instantly go dead when we got inside. Had I been selling AA batteries, I could have retired. But when we would come outside, they charged right back up. It also seems to have an effect on people.

One night, Chuck and I were standing on the stage, and all of a sudden, Chuck felt completely drained of energy and nauseous and had the

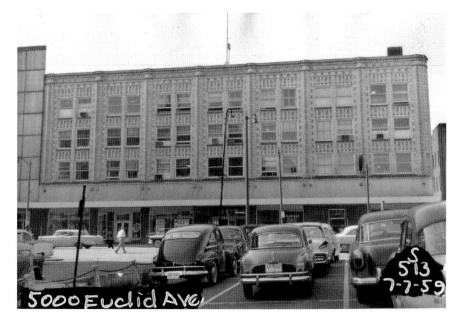

The building at 5000 Euclid Avenue before it became the Agora. *Courtesy of Cleveland Public Library Photograph Collection.*

beginnings of a headache. He actually had to sit down. I was concerned that I would have to finish the tour on my own. But amazingly, the minute we went outside, Chuck felt fine. He said it was like a weight was lifted off him. The really strange thing was that was one of the nights when we had people get picture after picture with orbs in them. Maybe the ghosts drained Chuck's energy to be more visible to our guests that night.

There are many ghost stories attached to the Agora, but one of the most talked about is the man in the yellow coat. A young man said that one night he was at a rave at the Agora, and he was in the stairwell. The party was in full swing, and a guy passed him going up the stairs. When the guy got to the landing, he dropped a bottle of what I am sure were totally legal pills. During the mad scramble to help the gentleman pick everything up, the young man felt the hair on his neck stand up, and he looked up and saw a man in a yellow coat standing on the stairs. He had a very stern look on his face as he looked at the kid, looked at the pills and shook his head no—and then he just disappeared. The kid immediately stopped what he was doing and sobered up—talk about scared straight! Even later, while telling the story, the hair on this poor guy's arm was standing up. He said he felt like the man in the yellow coat saved his life, and he said he just knew something bad would have happened without the man's warning.

Once there was a photographer taking publicity pictures for the Agora, and when he got there, he went into the large theater and asked the cleaning staff to leave him alone so he wouldn't have to worry about them getting in the pictures. As he was taking pictures, he heard one of the doors open and close. He assumed someone had come in and turned to ask them to leave, but to his surprise, he was still alone. So he turned back to the balcony and saw a woman sitting there. He started to yell out to ask if she needed something, and he noticed that she had a long dress on. After he got over his surprise at her clothing, he opened his mouth to speak again, and she disappeared. Shocked, he ran out to talk to the cleaning staff. They all smiled and laughed a bit as they said, "Oh, she came to visit you? We see her all the time. She pretty much leaves us alone now." Some people believe she is the spirit of a lady of the evening brought in to entertain the actors when the building was still the Metropolitan and the party got out of hand. Others think she may be an actress who once performed there and was killed in an accident in the theater. Whoever she is, there are many people who feel her presence on the balcony and in a room downstairs in the basement.

One night I fell into conversation with a young man who had once worked as a bouncer here. He said part of his job was to help clean up after shows

The basement room in the Agora where people have reported the presence of a female spirit. *Courtesy of Brian Jecker.*

and wait until everyone had cleared out so he could lock up. Being the last one in the building was a little bit creepy, but he said he had no supernatural experiences at first. He just turned out the lights and left. After the first couple nights, he felt more comfortable being alone in the building, but he said he believed it was the calm before the storm because after that is when things started to get out of hand. He said that it started with just hearing footsteps on the catwalk, the first couple times he checked it out then he realized no one else (living) was there. Then he would catch something out of the corner of his eye. Still, he was OK; it was a good job, and he liked it there. Then one night, whomever was in the Agora with him pushed him to his limit. He heard the footsteps on the catwalk as he was heading to the door in the large auditorium, and then the footsteps sounded like someone ran past him and threw open the door. He calmly went about the business of locking up, turned in his keys the next day and never went back.

There was a ghost-hunting group that came in to investigate, and while they were on the catwalks high above the stage, they decided to do an EVP session. In an EVP session, people use a digital recorder to ask spirits questions, and hopefully the recorder picks up answers. The group members all felt unwelcome on the catwalk, and one of them felt like

CHAPTER 13

SQUIRE'S CASTLE

As part of the North Chagrin Reservation of the Cleveland Metroparks, Squire's Castle now stands in a beautiful grove of trees. It was built by Feargus B. Squire, an executive for the Standard Oil Company. Squire wanted a country estate, so he bought 525 acres in what is now Willoughby Hills. Being English born, he had definite ideas of what he wanted his manor house to look like, and his estate was planned to look like an English country estate, complete with a caretaker/hunting lodge, which is the only portion that was ever completed. When Squire began designing his estate, he planned to use as many local materials as possible, so the caretaker/hunting lodge is built with stones that were quarried right on the property.

Work started on the estate, and being a lover of country living, Feargus wanted to spend all his spare time on the estate. Unfortunately, Mrs. Rebecca Squire was a city girl and would have preferred the hustle and bustle of city life, not the serenity of country living, but she did consent to spending time on the estate. As the story goes, Rebecca became more and more distraught over country living and began to suffer from insomnia. She began to wander throughout the house at night, guided by the light of a red lantern. One night, she is said to have become startled by something, perhaps one of her husband's hunting trophies and, in a panic, fell down the basement stairs and broke her neck. To this day, there are reports of people seeing the glow of a red lantern moving through the house, possibly the spirit of Rebecca Squire wandering endlessly through the home she never wanted to live in.

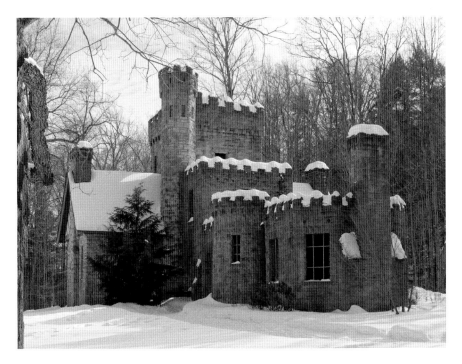

A photograph of the exterior of Squire's Castle. *Courtesy of Beth A. Richards.*

Now here's the interesting part of the story: Mrs. Squire didn't die in the house. The estate was never completed—whether because Feargus had lost interest or because of his wife's unhappiness, we will never know—but he sold the land in 1922, and the Metroparks acquired it in 1925. Mrs. Squire is believed to have died in Wickliffe in 1929, surrounded by noise and people. Is it possible that Mrs. Squire went back to a place that terrified her in life to endlessly wander? I wouldn't think so, but you never know.

When we first started using Squire's Castle on our tour, I resisted because I knew that Rebecca Squire didn't die at the house, but it's really a great story and a great location. I didn't want to mislead our guests with a story that wasn't true, but amazingly enough, we had guests bringing back picture after picture of red orbs. I was stunned.

On one tour, there was a man who came back to the bus, obviously shaken. He had attracted my attention almost immediately because he was one of the husbands forced to come on the tour (you can always recognize them). I asked if he was OK, and he just got on the bus silently. His wife was behind him, and she laughed and said, "He's fine. Something touched

The center of Squire's Castle. *Courtesy of Joel Craig.*

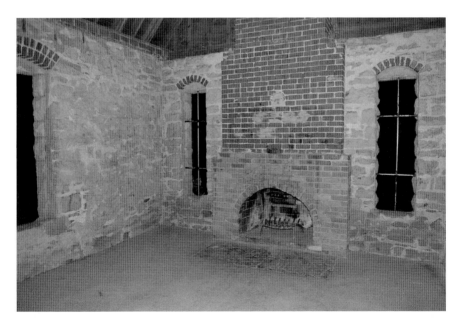

This was considered the trophy room of Feargus Squire, where legend says Rebecca Squire became frightened during her nighttime wandering and fell to her death. *Courtesy of Joel Craig.*

him in the castle when he was in front of the fireplace by himself, and now he's all freaked out." She came back on the tour the next year, but her husband must have had other plans that evening. I guess maybe Rebecca wanted someone else to be as bothered about being in the country as she had always been.

The years that we have used Squire's Castle on our tour, it was usually pitch black in the Metroparks, so I would tell the story of Squire's Castle on the bus and let Chuck lead the group up to the castle. It's not that I was afraid of the spirit of Rebecca Squire, but I do have a healthy respect for the dark. Chuck and I would use a CD of horror movie music on the tour to set the mood, and there was a song from *The Exorcist* that used to really give me the chills. One night, Chuck asked me to take the group up, so I did, and when I got back to the bus, that song was playing. I didn't say anything at the time, but when we got to the next stop and I got back on the bus, it was playing again; the next stop, the same thing. By this time, I was really wondering if there was a ghost following me, trying to scare me. At the end of the night, I finally said something, and Chuck burst out laughing. It turns out he had been playing the song over and over just to freak me out.

For several years in a row, we had a woman bring her young daughter on our tour as a birthday gift. The little girl seemed to really enjoy the tour, and she never seemed to get scared. Now, this was the time before digital cameras were the norm, and this young lady actually had a Polaroid camera that she used. She got some of the most amazing pictures I have ever seen, and she had many photos of Rebecca Squire's red orbs.

As a tour guide on a rented bus, I sometimes have to cross my fingers and pray that the sound system works, and I have usually been lucky, but one night, the sound system failed on me. It was working fine until we got to Squire's Castle, and all of a sudden, the bus lurched, like it hit a big bump. There was a creepy noise, and the sound went out. I thought perhaps my microphone had become unplugged, but it was still plugged in. The light on the sound system was on, but there was just no sound. Chuck and I unloaded the bus at Squire's and escorted our guests up to the castle, and our driver said he would look at it while we were gone. We came back, and no luck, it still didn't work. So we did the best we could for the rest of the night, and I forgot about it until the next week. Our driver pulled in to the Powerhouse and said, "You guys are not going to believe this, but when I took the bus back to the garage, I told the guys

that the sound system was broken." They told him they would check it out and get back to him. They called him a few days later and told him they found the problem: the wires in the sound panel looked like they had been ripped apart—not chewed up, not frayed, but ripped apart. I was shocked, and the only thing I could figure was that Rebecca Squire didn't want her story told that night.

A woman on our tour once told me that a friend of hers had her wedding photos taken at Squire's Castle. The woman said that the groom's face in every photograph seemed to be shadowed, and he had a red line through his body in almost every picture. The marriage didn't last for more than a year, and after their divorce was final, the groom died in a freak accident. After that, you can be certain I made sure my picture was never taken at Squire's Castle, just in case.

At the back of the house, you can see where it looks like an area has been filled in. This was the basement that workers filled in, and I heard an interesting story about why that happened. A person whom we had talked to about using it on the tour one year told us that she and a friend were the reason the basement had been filled in, and in fact, they were also the reason the legend of Rebecca Squire stayed alive. She informed

The back of Squire's Castle where the outside entrance to the cellar was located prior to it being filled in. *Courtesy of Joel Craig.*

us that her and her friend used to sneak out with a red flashlight and creep around Squire's Castle. One night, someone took offense to what they were doing, grabbed them and threw them in the basement to scare them. When it was reported, the basement was filled in. Again, this is her story, and I could never verify it, but it did make for an interesting twist to the Rebecca Squire legend.

You can visit Squire's Castle for yourself and see if the spirit of Rebecca Squire makes herself known to you. You just have to follow the red lantern and listen for Rebecca Squire's screams.

CHAPTER 14
FAIRPORT HARBOR MARINE MUSEUM AND LIGHTHOUSE

Located thirty-five minutes from downtown Cleveland is historic Fairport Harbor. The town was first named Grandon and was part of the Connecticut Western Reserve. A group of surveyors was sent to what is now Fairport Harbor in 1796 and 1797 by the Connecticut Land Company.

There is evidence of Erie Indians living in this area as early as the seventeenth century until their villages were destroyed by the Iroquois Indians.

In 1760, during an expedition to Detroit, Major Robert Rogers and his Rangers were forced to take shelter at the Grand River by Fairport Harbor, and this may possibly be the earliest visit by white men to this area.

There may have been settlers here before 1800, but there is no documented proof about who settled here first, as all the accounts vary, but there are published accounts of pioneer families traveling through here as early as 1798.

The town of Grandon was established on May 16, 1812, by Captain Abraham Skinner, Samuel Huntington and others, and the Grand River helped to create the port and the village. The name of the town was changed to Fairport in 1836, and later the "Harbor" was added to it.

The lighthouse was built by Jonathan Goldsmith and Hiram Wood, who had bid on the job, and in 1825, the first lighthouse and keeper's dwelling were completed for a whopping $2,900. There was a slight miscommunication during the planning stages, so an extra $174.30 had to be paid to the builders to complete the cellar. By 1831, Fairport Harbor became the first

federally sponsored port, and shipbuilding, fishing and transportation of goods created a thriving port.

Fairport Harbor was home to many people of English and Irish descent, but as the town grew, many Finnish, Hungarian and Slovak people immigrated to the area. Shipping increased with the establishment of the ore docks. Ore came into Fairport Harbor from the mines in Michigan and Minnesota and was transported out to steel mills in Youngstown, Ohio, and Pittsburgh, Pennsylvania. There is still limited traffic in the harbor, with sand and limestone being moved through the port, and rock salt is a major export.

The fifty-five-foot-tall lighthouse was first lit in the fall of 1825 as one of eight lighthouses located on the Great Lakes, and soon Fairport Harbor was a bustling port, rivaling the Port of Cleveland. The Fairport Harbor lighthouse was not just a beacon for ships but also a light of hope and freedom for escaped slaves. The community was very antislavery, so Fairport Harbor became one of the last stops on the Underground Railroad, hiding escaped slaves until they could be transported to Canada on one of the ships. The townspeople actively helped in any way they could, sometimes even hiding slaves in the lighthouse itself.

After some years, the lighthouse began to show signs of deterioration, so in 1871, a new tower was constructed. This one was sixty-eight feet tall, and on August 11, 1871, it was lit for the first time.

During the lighthouse's lifetime, there were minor improvements made, such as in 1892, when plumbing for running water was installed in the keeper's dwelling and a handrail was installed on the tower. As the lighthouse changed, so did the town, and on June 12, 1917, Congress appropriated $42,000 for a new lighthouse and fog station to be built on the west break wall. The new lighthouse was not completed until 1925, and it became fully operational on June 9, 1925, thus ending the reign of the light that was lit for one hundred years. When Congress had originally appropriated the money for construction, it included funds for the demolition of the old lighthouse. Fairport Harbor residents rallied around the stone lighthouse and began a campaign to keep the structure since it was a major part of their city's history. They were successful in convincing Congress to allow the lighthouse to stand. In 1945, the United States Coast Guard turned the lighthouse over to the town.

Unfortunately, the lighthouse continued to fall into a state of disrepair, and toward the end of World War II, town officials began to talk about demolishing the structure again. This time, the town fought back with the creation of the Fairport Harbor Historical Society, the main goal of which was to preserve the town's rich nautical history. The society turned the

lighthouse and keeper's dwelling into the country's first marine museum, the Fairport Harbor Marine Museum and Lighthouse. The museum features many great exhibits concerning the history of the lighthouse and its keepers, the United States Coast Guard and the history of boatbuilding in Fairport Harbor. The museum has even added the pilothouse of the Great Lakes carrier the *Frontenac* to the museum for people to experience. There is one exhibit, though, that I know is sure to get your attention.

Back in 1871 when Captain Joseph Babcock was the head keeper of the lighthouse, his family resided in the second-floor quarters. His wife was very ill and remained bedridden much of the time, so Captain Babcock gave her many cats to keep her company and to entertain her. When she passed away, all the cats disappeared from the lighthouse—all except one. A gray cat that people have taken to calling Sentinel hung around the lighthouse for many years, and some people believe Sentinel is still there.

Apparently even many years after Mrs. Babcock passed, Sentinel still visits people at the museum. Former curator Pam Brent resided on the second floor of the museum and reported that she saw a gray cat playing by the kitchen. The strange thing is that Pam Brent doesn't own a gray cat—or any cat, for that matter. She said the cat skitters around like he's playing, and one night he jumped into bed with her and she felt his weight on her. Many volunteers and visitors report feeling a cat rub up against their legs. They feel it, but they don't see it.

The time came to do some renovations on the museum, and the trustees decided to have air conditioning installed. A worker crawled into a very tight crawl space in the basement to do some work and felt something under his head. Imagine his surprise when he looked to see what it was and found himself face to face with a mummified gray cat. The mummified remains of Sentinel were on display at the museum until they mysteriously disappeared, but Sentinel has turned back up and is again on display at the museum. Sentinel has become quite a celebrity and has been featured on Animal Planet's show *The Haunted* and on the Discovery Channel's *Weird, True and Freaky*.

What I found so interesting about this story is that we were going to have a chance to maybe see a ghost cat! That was really the only thing I knew, that it was a ghost and it was a cat, no specifics. We went out to the lighthouse for an interview with a reporter from the *Plain Dealer*, and we were walking toward the lighthouse when I glanced over and saw a gray cat, sitting and staring at me. Was he real? Was he supernatural? I will never know the answer to that question because I turned around and walked the other way.

When I got home and found out that Sentinel was a gray cat, I must confess I wish that I tried to get a little closer just to satisfy my curiosity, although they say curiosity killed the cat!

Fairport Harbor Marine Museum and Lighthouse is opened seasonally, May 1 through November 1. You can check out its website for specifics, but do yourself a favor and explore the rich nautical history of this great little town. Maybe Sentinel will stop by and pay you a visit.

CHAPTER 15
AROUND THE TOWN GHOSTS

When we do our tour, we have stops where we go inside to investigate and other stops that I call drive-by stories. These are usually private residences or buildings that we cannot access at night. I want to take some time to share those ghosts with you also.

THE CLAGUE PLAYHOUSE

The Clague Playhouse is located at 1371 Clague Road in Westlake. The theater is actually located in a barn that was owned by the Clague family. The Playhouse is adjacent to the Clague House Museum, where the Westlake Historical Society is located.

The Clague Playhouse has its roots in a small theater group that was known as the Bay Village Players. The Bay Village Players performed anywhere they could until 1967, when they found out that the Clague home and barn could be rented. They formed a dual lease with the newly formed Westlake Historical Society to rent the house and barn and became known as the Clague Playhouse. The group opened to a packed house with a performance of *Sunday in New York* on November 30, 1967. In 1986, water damage caused the theater to be closed down for major renovation, but it came back in 1991 for the opening of its sixty-fourth season.

We used Clague Playhouse for our Gold Coast Ghost Tour one year, and the players were nice enough to write a skit about their ghost and

perform it for our guests. They shared with us the history of the Clague family and their ghost, Walter. Walter has been in the theater since it started in 1967, and he really seems to dislike change. Walter likes to play little tricks like making props disappear and startling people with strange noises. But one day he went too far with his pranks. One of the troupe members was painting in the lobby, and maybe Walter didn't like the new color or the fact they were making a change. First, the gentleman's paintbrush disappeared, and that was bothersome enough, but then the ladder, which was holding the paint can, was knocked over. After the paint was spilled, the gentleman decided to call it a day and hope that Walter would get used to the change.

JOHNNY MANGO'S

Johnny Mango's is a bar in Ohio City that has spirits and more spirits. It is said that there are a trio of ghosts that inhabit the bar. The staff has identified one of the oldest spirits as a woman named Margaret, who was killed in the Central Viaduct disaster when her trolley car plummeted off the bridge and went into the Cuyahoga River in 1895. There are some who believe she is a widow who left five children behind when she died and is now interred at Riverside Cemetery under a grave marker that reads "Mamma." The other two have not been identified, but employees do believe there are three separate spirits here. Patrons and staff report that glasses and plates seem to move on their own, and nighttime staff members tell stories of hearing voices and footsteps after hours when the bar is empty. It seems the trio is harmless; they just want to be noticed.

THE TERMINAL TOWER/RENAISSANCE HOTEL

This hotel was actually built in 1918 on the site of Cleveland's first hotel, and then in the 1920s, the Van Sweringen brothers built the Terminal Tower around it. It sits on historic Public Square and actually had one of the country's first indoor pools. The list of guests who have stayed in this historic hotel include the Beatles, Duke Ellington, Martin Luther King Jr. and numerous presidents, and the list goes on and on. Eliot Ness and his wife frequented this hotel often, and Ness held a suspect in the Torso Murders, Francis Sweeney, in the hotel for a week to question him.

This hotel has more than an impressive roster of guests that have stayed the night: it is also home to multiple spirits that make their presence known from time to time. Many report hearing footsteps in the Gold Room on the stage and also say that there is a weird electrical charge present in the atmosphere in the backstage area.

In the Carnegie Board Room, people have seen a man walking through the room out of the corner of their eye, and one man actually reported that something came up behind him and whispered in his ear, "You're doing a good job," and disappeared. At the end of the Stouffer Room, people have seen a man sitting at a desk smoking a cigar, and they have actually smelled the cigar smoke. And rumor has it that the cleaning staff tries not to be on the fourth floor alone at night.

THE FEDERAL RESERVE BUILDING

Located at the corner of East Sixth Street and Superior Avenue stands the Federal Reserve. This building was designed by Cleveland architectural firm Walker & Weeks in 1923. There have been a couple spirits reported throughout the Federal Reserve. A cleaning lady reports the spirit of a young lady dressed in flapper clothes making an appearance on the eighth floor, while another lady reported seeing a male apparition wandering the building at night.

THE DRURY MANSION

The Drury Mansion is located on Euclid Avenue and was built for industrialist Francis Drury, who made his fortune in cast-iron stoves. This fifty-two-room mansion was built in 1912 and has a broad center staircase, towers that loom over an interior courtyard and miles of twisting hallways with unexpected rooms opening up off them. There supposedly was even a tunnel that went under Euclid Avenue to the Drury Theater. The theater was built in 1914. Since the time of the Drury family, the home has changed hands many times. It was a boardinghouse, a home for wayward girls and then in 1972 it was leased to the Ohio Adult Parole Authority and became a halfway house for paroled convicts. It's hard to imagine that these hardened criminals could be frightened, but there were many reports from the parolees

about groaning sounds, windows that would open and close on their own, doors that wouldn't stay closed and footsteps echoing in empty hallways. Now these noises would be explained away with the expansion of the wood, the plumbing groaning and just overactive imaginations.

One story that cannot be explained away was told by one of the staff members. He was going up the main staircase, and there was the figure of a woman gliding toward him and then through him. Even though he was in complete shock he noticed that she had on a long, turn of the century dress and had her hair pinned up in a bun. She continued on her way and headed into the kitchen. As terrified as he was the first time he saw her, he quickly got used to having her around as she seemed to like the kitchen and was frequently seen there. He was never able to find out if she was a member of the Drury family keeping an eye on the family home or just a lonely spirit of another era. The Drury Mansion is now owned by the Cleveland Clinic Foundation, which uses it for meetings and other events.

FOX 8 Studio

The FOX 8 Studio is located on South Marginal Road heading east out of downtown Cleveland, and if we are doing our Lakefront Ghost Tour we drive past it on our way to other stops. The station has people inside working at all times of day and night, and the night staff has reported the appearance of a male apparition dressed all in black roaming the halls of the studio. For those of you who are Clevelanders—no, it is not Dick Goddard!

The *William G. Mather* Steamship

The *William G. Mather* Steamship Museum is located at Dock 32, west of the East Ninth Street pier. It is part of the Great Lakes Science Center. The *William G. Mather* was built by Great Lakes Engineering Works of Michigan and launched on May 23, 1925. The *Mather* ran up until 1980, when it was taken out of service, and it is now a floating museum. This ship was the flagship for the Cleveland-Cliffs Iron Company and was named in honor of the company's president. It is 618 feet long and can carry fourteen thousand tons of cargo. The *Mather* mostly carried ore, coal, stone and grain and was

nicknamed the "Ship That Built Cleveland" because most of its cargo ended up at one of Cleveland's many steel mills. The *William G. Mather* remained the company's flagship until 1952.

In early 1941 during World War II, the Allies needed steel, so the *Mather* led thirteen freighters through the icy upper Great Lakes to get to Minnesota. This was actually featured in *Life* magazine. In 1946, the *Mather* was one of the first Great Lakes vessels to be equipped with radar. It also became the first American vessel to have an automated boiler system, installed in 1964 and manufactured by Bailey Controls of Cleveland, Ohio.

The *Mather* was actually the last ship owned by the Cleveland-Cliffs Iron Company, and when the company was no longer using it, it was basically left to rust away at a shipyard in Toledo. In 1987, Cleveland-Cliffs donated the steamship to the Great Lakes Historical Society for restoration and preservation as a floating maritime museum. The *Mather* arrived in Cleveland in 1988, and its restoration began through the work of many volunteers and funding acquired from corporations, foundations and private donors. Originally, the *William G. Mather* was docked at the East Ninth Street Pier but recently made its way over to its new berth by the Great Lakes Science Center.

When we began to use the *Mather* on our tour, the volunteers performed theatrical ghost stories for us, and they were fabulous, but in talks with the then director of the museum, we learned that many of the volunteers had some unexplained experiences. Some of the volunteers mentioned that while in the captain's cabin area, they repeatedly heard the sounds of children laughing and playing—the only thing missing was the actual children. Other volunteers have reported that while they were working in the galley after the restoration was complete, they would hear the unmistakable sounds of people cooking meals. They heard the pots and pans clanging around and what sounded like people talking. They also heard the sounds of chairs moving around in the crew's dining room. It is truly as if the crew never left the *William G. Mather*.

The *William G. Mather* is open from May through October for tours.

BRATENAHL GHOST STORIES

Bratenahl is a small city close to downtown Cleveland. The city has some magnificent lakefront homes and has a rather affluent reputation. Both of these stories were passed on to me by my Auntie Rose, and they were

told to her by her mother, who used to housesit for people in Bratenahl. Granny actually had an experience with one of the spirits while she was housesitting.

There is a stately white home located in Bratenahl that can be seen from the main street. At one time, this home had a full staff to tend to it and the family who lived there. The butler was in charge of the house and the staff, and he took his job very seriously. Every night when the family retired, he checked the house from top to bottom to make sure everything was in perfect order for the next day. For years, he did this task, and apparently it carried into his afterlife. There have been many stories told by people who have seen a man dressed in butler's livery coming down the staircase and going throughout the house carrying out his late-night jobs. One night while Granny was there, she was startled to see the butler for herself. She said he stood at the top of the stairs and started down the steps, only to fade away from sight. She said that rather than feeling scared, she actually felt comforted that he was making his rounds of the house.

We would stop the bus in front of the house while I would tell the story, and after six weeks of tours, the house went up for sale. I joked that the folks who lived there were either disturbed by the butler or by the fact that a tour bus kept parking outside of their house. Amazingly, the next time we used this stop and story, the same thing happened, and four weeks into the tours, the "For Sale" sign went up again.

The house in Bratenahl where our next supernatural experience took place is long gone, but the story has stayed around. I'm sure most everyone has seen the movie *The Exorcist*—the little girl with a spinning head, pea soup and levitating off the bed. You may ask yourself if things like this actually happen, and my answer is yes—at least once in Bratenahl. The story goes that one winter evening, a young girl was walking home and a car pulled up next to her and offered her a ride. She thought it was a neighbor at first and she got in the car, but when she looked over at the driver, it had changed forms, straight down to the cloven hooves. Unlike the movie, the demon did not possess the young girl's body; instead it attached to her, slowly driving her insane. Her parents were at the end of their rope, so they turned to their parish priest to see if he could help her. He requested permission to perform an exorcism, and it was granted by the diocese.

When he got to the house to start the exorcism, the demon was infuriated. Chairs were thrown around the room, and pictures were spinning on the

walls so fast that they were leaving scorch marks. Everywhere the priest threw holy water, clouds of smoke were rising. He kept going until the demon was driven from the house. There was a loud explosion, and a huge ball of smoke shot out the front door. On closer inspection, there were hoof prints leading away from the house.

In another strange twist that mimics the movie, the priest who exorcised the demon met with an extremely violent and tragic death. He was decapitated in an automobile/train accident at a railroad crossing. The young woman survived the ordeal, became a cloistered nun and lived a very long and sheltered life.

CONCLUSION

These are some of our favorite haunted locations to visit in Cleveland, but there are many more. Over the years, we have changed our tour, and we have delved into different periods of history in Cleveland.

On our tours, we have talked of Cleveland's organized crime and when Cleveland was referred to as the bombing capitol of the country. We have explored different tragedies that have occurred here, such as the Collinwood School Fire and the East Ohio Gas explosion and how these horrific events have left an echo of sadness at their locations.

The most amazing part of doing this job is finding out the amazing history of these locations and meeting the wonderful people who are the caretakers of some of the most interesting places in Cleveland. We have always strived to share a true history of all of our locations and pass on the legends we have heard. It is truly a bonus when we get some sort of photographic evidence or someone on our tour has an unexplained experience.

The one thing we like to impress on our guests is that if they are doing any ghost hunting on their own, they need to do it in a respectful manner, obey the law (no trespassing on private property), do no harm to any of the public locations and, above all, be safe.

This is a great hobby for both history buffs and believers in the supernatural. You can do this with some basic equipment, such as a digital camera and a digital recorder, or you can go all out and get an EMF detector and dowsing rods.

In all the years of doing this job, I have had many people ask me, "Aren't you afraid a spirit will follow you home?" or "How can you walk through a cemetery at night and not be afraid?" My response to these folks is always the same. I say, "I always take my dad's advice on this: it's not the dead you have to worry about, it's the living you need to fear."

Chuck and I have truly enjoy showing people a spectral side of Cleveland on our tours and sharing the history of a fascinating city and look forward to doing it for many years to come. As I always say at the end of the tour, from Haunted Cleveland, Chuck and myself, I hope you have enjoyed your time with us, and happy ghost hunting!

GLOSSARY OF TERMS

APPARITION: A supernatural appearance of a person or thing; a ghost.

DOWSING RODS: Dowsing rods are used to locate groundwater, metal or, in some cases, spirit energy. They can also be used to locate grave sites. They can be a Y-shaped stick or two metal rods. Paranormal investigators also use them to communicate with spirits.

EMF METER: Electromagnetic field meters can be used to measure fluctuations in the electromagnetic field, which some say is an indication of the presence of spirit energy.

EVP: Electronic voice phenomena; sounds and words found on electronic recordings. Paranormal investigators often use digital recorders to try to communicate with spirits.

EXORCISM: A process or ceremony that is used for getting rid of an evil or unwanted spirit.

GHOST: Spirit of the deceased.

GHOST HUNTING: Investigations of places reported to be haunted by ghosts using a variety of equipment, such as EMF meters, digital thermometers, EVP recordings, video recordings and digital cameras.

MEDIUM: A person who possesses the ability to communicate with the spirits of the dead.

ORB: A globe-shaped spot, white or colored, that generally shows up at alleged haunted locations. People believe these orbs are spirit energy.

OUIJA BOARD: Also known as the spirit board, or talking board, it is a flat board that has the alphabet, numbers and sometimes words printed on it. It is used with a planchette that can spell out words and can communicate with the dead.

PARANORMAL: Used to describe phenomena that are beyond the scope of normal scientific understanding, such as clairvoyance and telekinesis.

SOURCES

Ancestry.com. Cuyahoga county archives. www.homepages.rootsweb.ancestry.com.

Blum Vigil, Vicki. *Cleveland Cemeteries Stones, Symbols & Stories*. Cleveland, OH: Gray & Company, Publishers, 1999.

Clague Playhouse. www.clagueplayhouse.org.

Cleveland Metroparks. "Squire's Castle." www.clevelandmetroparks.com.

Cleveland Police Museum. About the Museum. www.clevelandpolicemuseum.org.

Curtiss, J.M. *Historical Review of Riverside Cemetery*. Cleveland: The Cleveland Printing & Publishing Co., 1889.

Encyclopedia of Cleveland History. www.ech.cwru.edu.

Fairport Harbor Lighthouse, Ohio. Lighthousefriends.com, Fairportharbor.org/about/history and www.fairportharborlighthouse.org.

Grays Armory. "The Museum, History." www.graysarmory.com.

The Hermit Club. http://www.thehermitclub.org/about/history.

Mote, Patricia M. *Cleveland's Playhouse Square*. Charleston: Arcadia Publishing, 2006.

Riverside Cemetery. "History and Prominent Residents." www.riversidecemetery.org.

Soldiers' and Sailors' Monument. "Monument Story." www.soldiersandsailors.com.

USS *Cod*. "About the USS *Cod*." www.usscod.org.

About the Authors

Courtesy of Bonnie Brihan, Bonnie B Photography.

When Chuck came up with the idea of Haunted Cleveland Ghost Tours, it was really to give adults a different way to celebrate Halloween and to explore the history of Cleveland. As lifelong Clevelanders, Beth and Chuck have used their knowledge of Cleveland and all the legends they have researched to take people on a trip through a different kind of Cleveland, one filled with things that go bump in the night. By changing the tour every year, they add in new experiences for their guests while still keeping some old favorites.

Beth and Chuck love to discuss the ghostly history of Cleveland and have been on many of the local news shows sharing tales of Cleveland, their tours and the experiences of their guests.

Chuck is a detective in the Cleveland Homicide Unit who has been planning tours for Haunted Cleveland for over a

decade. He is a member of the Cleveland Police Historical Society and the Western Reserve Cleveland Firemen Museum and Education Center. He has always had an interest in local history and is constantly looking for new ways to celebrate his favorite holiday, Halloween.

Beth is an office manager for a downtown court reporting firm. She spends much of her day verifying information, so to move on to researching local history and the ghosts of Cleveland seems like a natural progression—to her, at least. Beth loves Cleveland, and some of her earliest memories are of spending time exploring downtown Cleveland. She has always been interested in ghost stories, possibly due to the fact she grew up in a century-old home that seems to hold an echo of the past.

Beth and Chuck both agree that the greatest pleasures of their job are showing Clevelanders places in the city they have never visited, sharing the rich history Cleveland has to offer and showing tourists just how amazing the city is, both now and in the past.